45 P

GREAT ARTISTS COLLECTION

Five centuries of great art in full colour

BRITISH PORTRAIT PAINTERS

by ROBIN GIBSON & KEITH ROBERTS

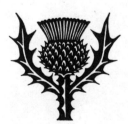

ENCYCLOPAEDIA BRITANNICA : LONDON

Volume thirteen

COVER: Detail from *Mrs Abington as Roxalana in 'The Sultan'* by Sir Joshua Reynolds (Private Collection)

© 1971 by Phaidon Press Limited, London

This revised edition published in 1972
by Encyclopaedia Britannica International Limited, London

ISBN 0 85229 113 2

Printed in Great Britain

BRITISH PORTRAIT PAINTERS

IN THE MIDDLE AGES, portrait painting as we understand the term did not exist. Social conditions did not encourage it; and for the most part artists would have been incapable of providing adequate likenesses. Physiognomy, the quirks of the individual face, were not part of a painter's interests. But with the fifteenth century the situation changes as the Renaissance creates a new intellectual atmosphere in which the spirit of inquiry is dominant. On the Continent great artists like Jan van Eyck—who died in 1441—produced portraits that have hardly been surpassed for acuteness of characterization.

Britain, unfortunately, produced no native genius of equal stature, and, as so few portraits from the fifteenth century have survived, the record now seems even more depressing than it probably was. Being secular objects, portraits were not kept safe in churches; the unsettled times did not encourage the safe preservation of fragile works of art. The few surviving British portraits from this period lack vitality, partly because they were seldom taken from life. The portrait of Richard II in the *Wilton Diptych* (Plate 1) gains much of its aesthetic quality from the religious context in which it is set: the unknown artist was able to draw on the long, subtle tradition of religious painting for his imagery.

The first major artist in the history of British portrait painting was the German, Hans Holbein the Younger (1497/98–1543), who spent two periods of his life in Britain, the second from 1532 until his death eleven years later. He brought greater refinement of execution, more considerable powers of composition and a keener eye for a likeness than had ever been seen here before. Towards the end of his career, Holbein's portraits became more decorative and less three-dimensional in effect (Plate 2). This tendency was to have extremely important consequences for British painting until well into the seventeenth century. The appearance of much Elizabethan painting is flat and decorative.

Mary I, Elizabeth I and James I were not especially interested in the visual arts, and as royal patronage was essential if the arts were to flourish abundantly, achievements between 1550 and the early 1630s were not as high as they might otherwise have been. The religious revolution, involving the establishment of the Protestant faith, had its own disastrous impact on painting. There was no longer any need for religious works, and contact with such vital sources of talent and ideas as (Catholic) Italy was reduced to a minimum. However, the age produced several artists of talent, such as Eworth (Plate 3) and the younger Gheeraerts (Plates 5 and 8), and two miniaturists of genius: Nicholas Hilliard (Plates 6b and 6d) and Isaac Oliver (Plate 7).

Plate 1. UNKNOWN ARTIST: *Richard II presented to the Virgin and Child by his Patron Saints* (left half of the *Wilton Diptych*). About 1395–9. Oak panel, 46 × 29 cm. London, National Gallery.

At the end of the fourteenth century, portraits were usually painted only to mark special occasions: coronations, marriages or events with a religious connotation. It is possible that this portrait was connected with a Crusading Order of the Passion. It is part of a diptych, and the right panel shows the Virgin and Child surrounded by angels. This picture should not be regarded as a portrait in the modern sense. As the gold background itself implies, the nature of the image is essentially symbolic and embodies a flattering view of royal piety.

Plate 2. HANS HOLBEIN THE YOUNGER (1497/98–1543): *Henry VIII.* 1536(?). Panel, 27 × 20 cm. Lugano, Thyssen Collection.

This small panel is the only painting of Henry VIII (1491–1547) from Holbein's own hand to survive. He is shown with shaved hair and with a beard, changes in his appearance that he made in May 1535, in emulation of the French king, Francis I.

Plate 3. HANS EWORTH (active 1540–1574): *Lady Dacre.* About 1555. Panel, 74 × 57 cm. Ottawa, National Gallery of Canada.

Hans Eworth is a very interesting artist, and the most important resident painter in Britain between the death of Holbein and the emergence of Hilliard (Plates 6b and 6d). This portrait belongs still to the tradition of Holbein, but the design is less rational and the overall effect more decorative. In the background is a portrait of Lady Dacre's husband, Thomas Fiennes, 9th Baron Dacre (1517–1541).

Plate 4. UNKNOWN ARTIST: *Elizabeth I when Princess.* About 1546. Panel, 109 × 82 cm. British Royal Collection (reproduced by gracious permission of Her Majesty the Queen).

Probably painted for Henry VIII; recorded in the 1547 Inventory of Edward VI's collection, though the artist is not specified. Elizabeth (1533–1603) was about thirteen at the time, and there could hardly be a more touching contrast than between this tender portrait of the grave girl and the fantastic image of the aging queen painted forty-five years later (Plate 5). The artist is not known, although a case has lately been made out by Roy Strong for identifying him with William Scrots, who came to England in the autumn of 1545 and succeeded Holbein as King's Painter, at an annual salary of £62 10s.

Plate 5. MARCUS GHEERAERTS THE YOUNGER (c. 1561–1635): *Elizabeth I.* 1592. Canvas, 241 × 152 cm. London, National Portrait Gallery.

One of the grandest and most impressive portraits of the queen, this picture is traditionally said to have been painted to commemorate her visit to the home of Sir Henry Lee at Ditchley in Oxfordshire; Elizabeth stands on a map of England with her feet on the county. Portraits of this type were made essentially for propaganda purposes, and designed to emphasize the majesty of office.

Plate 6a. HANS HOLBEIN THE YOUNGER (1497/98–1543): *Mrs Pemberton.* About 1540–3. Water-colour on card, 5·4 cm. diameter. London, Victoria and Albert Museum.

No surviving miniature can be documented as by Holbein; but on grounds of quality this one has the best claim to be by him. It is inscribed with the age of the sitter (23), who is probably Margaret Throckmorton (died 1576), the wife of Robert Pemberton (died 1594). Miniatures were usually painted in water-colours that fade with repeated exposure to strong light, and consequently were often set in lockets or kept in elaborate and specially made ivory cases.

Plate 6b. NICHOLAS HILLIARD (c. 1547–1619): *A Young Man.* 1588. Water-colour on card, 6 × 5 cm. London, Victoria and Albert Museum.

The young man clasps a woman's hand, which emerges from a cloud—perhaps intended as a visual metaphor for the man's constancy even in the face of death. The Latin inscription *Attici amoris ergo* has so far defied elucidation.

Plate 6c. SAMUEL COOPER (1609–1672): *James II as Duke of York.* 1661. Vellum, 8 × 6 cm. London, Victoria and Albert Museum.

As a miniaturist, Cooper enjoyed a European reputation and from 1660 until his death produced an unrivalled series of portraits of Charles II, his family and court.

Plate 6d. NICHOLAS HILLIARD (*c.* 1547–1619): *A youth leaning against a tree among roses*. About 1588. Water-colour on card, 14 × 7 cm. London, Victoria and Albert Museum.

This is one of the most beautiful of all Elizabethan miniatures. The theme of love-sickness, emphasized by the Latin inscription (which means 'My praised faith causes my sufferings'), is familiar from English poetry of the time.

Plate 7. ISAAC OLIVER (died 1617): *Richard Sackville, 3rd Earl of Dorset*. 1616. Water-colour on card, 23×15 cm. London, Victoria and Albert Museum.

One of the largest and most impressive of Oliver's miniatures, this portrait reproduces, in a tiny format, the decorative style fashionable in full-scale oil paintings and reflected, with particular clarity, in the work of Oliver's brother-in-law, Marcus Gheeraerts the Younger (see Plates 5 and 8).

Plate 8. MARCUS GHEERAERTS THE YOUNGER (*c.* 1561–1635): *Mary Throckmorton, Lady Scudamore*. 1614/15. Panel, 114 × 83 cm. London, Tate Gallery (on loan from the National Portrait Gallery).

This is a fine example of Jacobean portraiture, although the careful attention paid to textures, and the overall decorative effect, still proclaim strong links with the Elizabethan tradition—indeed, Gheeraerts was also the painter of the Ditchley portrait of the queen (Plate 5).

Neither Elizabeth nor James I had been much concerned with the visual arts. But as if to redress the balance, and make up for decades of lethargic response, Charles I (reigned 1625–1649) became the greatest royal collector and patron of the arts that Britain has ever seen. He was not alone among his contemporaries: the Earl of Arundel, the Duke of Buckingham and his own ill-fated elder brother, Henry, Prince of Wales, all collected: but he was by far the most successful. Aware of the provincialism of English painting, Charles, as soon as he became king, paid a good deal of attention to the problem of finding a portrait painter capable not only of creating glamorous images that would embody his own regal aspirations, but also of producing pictures that could hold their own when judged by the most sophisticated continental standards of the day. At first, Charles had to be satisfied with Daniel Mytens (*c.* 1590(?)–1647), a competent, attractive but not particularly inspired artist. Then he came into contact with Van Dyck (1599–1641), whom he knighted in July 1632, and who continued to work for him until his death nine years later. The choice of artist reveals shrewdness as well as sensitivity: it is through Van Dyck's images of Charles as the elegant and refined cavalier that posterity still first sees and sympathizes with the unfortunate king. Van Dyck has probably had a more pervasive influence on British art than any other single painter. Dobson (Plate 11), Lely (Plate 12), Kneller (Plate 13), Gainsborough (Plates 27 and 31), Reynolds (Plate 28), Ramsay (Plate 20), Lawrence (Plate 33) and Sargent (Plate 44) all profited by his example, adapting his poses and imitating his brushwork.

Plate 9. SIR ANTHONY VAN DYCK (1599–1641): *Lady Shirley* (detail). 1622. Canvas, 213 × 131 cm. Sussex, Petworth House (National Trust).

Elizabeth or Teresia, Lady Shirley, was a Circassian noblewoman of Christian faith. She married Robert Shirley (1581–1628), who served as an envoy for the Shah of Persia. So as to provide himself with a Western equivalent to the Persian honours that had been conferred on him, he called himself Sir Robert or Count Shirley. This portrait and its companion of Shirley (which is also at Petworth) were painted in 1622 in Rome, at a time when he was Persian ambassador to Gregory XV.

Plate 10. SIR ANTHONY VAN DYCK (1599–1641): *Philip, Lord Wharton.* 1632. Canvas, 133 × 106 cm. Washington, D.C., National Gallery of Art (Mellon Collection).

This portrait of a gilded youth of the Caroline court, painted in 1632, when the sitter was nineteen, is a typical example of Van Dyck's more fanciful type of imagery. Refined, sensitive, aloof, Wharton is also seen to be dignified and pre-eminently aristocratic—note those long, supple fingers, which have never known a day's work. The landscape background and the shepherd's crook, suggestive of country pursuits, are not meant to be taken seriously: the allusion belongs to the same intellectual atmosphere as the masque, that charming combination of charade and poetry recitation which was extremely popular at court.

Plate 11. WILLIAM DOBSON (1611–1646): *Endymion Porter.* About 1643–5. Canvas, 150 × 127 cm. London, Tate Gallery.

Dobson died young and his output was relatively small, at least compared with that of Van Dyck and his efficiently run studio; but he remains the finest purely British painter to emerge before Hogarth. Very little is known about him. His most active and well documented period belongs to the early 1640s, during the Civil War. A comparison between *Endymion Porter* and *Philip, Lord Wharton* brings out well the particular tone and mood of Dobson's work. His portrait is less effete, less consciously elegant, and his handling of pigment is not as smooth, just as his colouring is not as gently harmonious. Endymion Porter (1587–1649) was a patron of artists and poets, and a friend of Charles I, on whose behalf he purchased works of art.

Plate 12. SIR PETER LELY (1618–1680): *Mary II when Princess.* About 1672. Canvas, 123 × 98 cm. British Royal Collection (reproduced by gracious permission of Her Majesty the Queen).

Born at Soest in Westphalia, Lely was trained in Holland, but was in England by 1647, when he painted the semi-captive Charles I and the younger royal children. After the Restoration, he was appointed, in 1661, Principal Painter and given an annual pension of £200 'as formerly to Sr Vandyke.' Lely's debts to the work of Van Dyck were considerable, as may be deduced by comparing this portrait with *Philip, Lord Wharton.* There is the same format, a similar emphasis on rich stuffs and a comparable use of symbolism: the young princess is 'disguised' as Diána, the classical goddess of the chase.

Plate 13. SIR GODFREY KNELLER (1646(?)–1723): *Sir Christopher Wren.* 1711. Canvas, 124 × 100 cm. London, National Portrait Gallery.

Kneller, a German by birth, like Lely, was in England by 1676, after periods spent in Holland, Italy and France. He eventually became Britain's leading portraitist. This famous portrait of Sir Christopher Wren (1632–1723) is typical of his work: well composed, fluently painted and with all the details in harmony. On the table to the left is a book lettered [E]uclid, while under it can be glimpsed a plan of the west end of St Paul's Cathedral, which was begun in 1675 and completed in 1710. As this portrait was painted in the following year, it may well have had a commemorative purpose.

The eighteenth century has been aptly named *The Golden Age* of British portrait painting. With a stable monarchy at home and the spread of political and cultural influences abroad, there had arisen a strong native school of painting and a prosperous public able to afford and appreciate, if not all branches of art, at least portraits of their families and friends. The lack of interest in the visual arts shown by the first two Hanoverian kings, George I and George II, meant that while

masters such as Hogarth (Plates 14 and 17) received little official recognition, they had less to face in the way of imported competition.

Hogarth stands alone in the post-Kneller generation of painters, who worked either in a rather effete pastoral style like Charles Jervas (*c.* 1675–1739), or in the uninspired realism of which Thomas Hudson (1701–1779) and Joseph Highmore (Plate 16) were the most efficient exponents. His virtuoso technique and brilliant characterizations set new standards for portrait painting. Both he and the gifted Scottish painter, Allan Ramsay (Plate 20), were successful in adapting French influences to their own styles.

From the mid 1750s until his death in 1792, the scene was dominated by Reynolds (Plates 21 and 28). As first President of the newly formed Royal Academy, he did much to raise the level of teaching and the social standing of artists. George III, who took an interest in the affairs of the Academy, patronized several of its members, including Gainsborough (Plates 18, 22, 27 and 31), perhaps the greatest artist in an outstanding age.

While Reynolds and followers like Romney (Plate 30) sought to raise portraiture to the level of high art with drapes and columns, the peculiarly English and realistic genre of the conversation piece reached its zenith in the work of Hogarth (Plate 17), Devis (Plate 19), Gainsborough (Plate 18) and Zoffany (Plate 23), and there was a revival in miniature painting with artists like Richard Cosway (1740–1821).

Plate 14. WILLIAM HOGARTH (1697–1764): *The Wollaston Family.* Signed and dated 1730. Canvas, 99 × 124 cm. Leicester, City Art Gallery (on loan from the Trustees of the late Mr H. C. Wollaston).

Hogarth began life as apprentice to a silver-plate engraver. He then turned to painting and made a speciality of the relatively new genre of small-scale conversation pieces, of which this is one of the largest and most ambitious. The prosperous Suffolk merchant, William Wollaston, is seen with his wife, friends and relatives, taking tea and playing cards in the drawing-room of his London house. Hogarth's genius for composition can be seen in the careful arrangement of the sixteen figures. The paint sparkles over the canvas and reflects the curvaceous quality of the rococo grouping. Although Hogarth's later portraits tend to be larger in scale, the pattern of conversation pieces was carried on in his well-known series of paintings with a moral, such as *The Rake's Progress.*

Plate 15. PHILIP MERCIER (1689–1760): *Frederick, Prince of Wales, and his Sisters.* 1733. Canvas, 45 × 58 cm. London, National Portrait Gallery.

The son of a Huguenot tapestry worker, Mercier came over to England about 1716, bringing with him a specifically French flavour in his small, rococo groups of figures. From 1729 until 1736, he was Principal Painter and Librarian to Frederick, Prince of Wales (1705–1751), the eldest son of George II. The Prince, playing the bass viol, is seen here with his sisters in front of the Dutch House at Kew, the residence of the Princess Royal. Frederick was a keen musician and patron of the arts; but despite the placid air of the scene, he is known to have been on poor terms with his sisters at the time.

Plate 16. JOSEPH HIGHMORE (1692–1780): *Mr Oldham and his guests.* About 1750. Canvas, 105 × 130 cm. London, Tate Gallery.

Highmore was one of the best, although least well known, contemporaries of Hogarth (Plates 14 and 17) and had a long career in London as a respected portraitist. For the most part, he did not manage to break through the conventions of contemporary portrait painting as Hogarth did, but in one or two instances, such as this one, he has given us some of the most direct and sincere portraiture in English art. The painting is unique in its own way, in that it records an informal

and intimate event, like a modern snapshot. Highmore's friend, Nathaniel Oldham, is seen arriving back late to dinner to find his guests, including Highmore himself in the cap, already drinking punch. In its robust realism, it goes beyond the artificiality of early eighteenth-century culture and takes us into the world of Smollett and Sterne.

Plate 17. WILLIAM HOGARTH (1697–1764): *Hogarth's Servants.* 1745–50(?). Canvas, 62 × 74 cm. London, Tate Gallery.

Despite his blunt and often savage approach in his moralizing pictures, Hogarth was not above flattering his high-born patrons. In this astonishing study of the heads of his servants, however, he is able to depict each one in depth and with great realism. Each head is an experiment in virtuoso painting and characterization, with models who were constantly at hand. In its directness and spontaneity it is close to Highmore's *Mr Oldham and his guests* (Plate 16), although it far surpasses it in brilliance of technique and colour.

Plate 18. THOMAS GAINSBOROUGH, R. A. (1727–1788): *Mr and Mrs Andrews.* About 1750. Canvas, 70 × 119 cm. London, National Gallery.

Gainsborough was born in Sudbury, Suffolk, and after a period of study in London, returned and settled in Ipswich, where he painted portraits of the local gentry like Mr and Mrs Andrews. His gifts were unknown at this early period of his career, but he had already developed an original landscape style. Completely natural and English in its effect, it was evolved to some extent from his study of Dutch paintings in local collections. His genius for clear and fresh observation in landscape is also applied to the portraits. Mr Andrews and his wife are seen resting on their estate after an early autumn afternoon's shooting, and are depicted with great naturalism and charm. The exquisite refinement of technique and the combination of portraits with landscape are entirely Gainsborough's own and are a new development in British painting.

Plate 19. ARTHUR DEVIS (1711–1787): *Edward Rookes Leeds and his family.* About 1760. Canvas, 102 × 127 cm. English Private Collection.

Born in Lancashire, Devis lived an uneventful life, travelling round the country painting conversation pieces of country families. Although he was producing his little groups of figures soon after Gainsborough's early small-scale portraits (Plate 18) and Hogarth's masterpieces in this genre of the 1730s and 1740s (Plate 14), Devis's paintings are quite without parallel in European art. He brought a certain minuteness of finish and detail to his figures, giving them a slightly primitive and doll-like quality, which never detracts from their charm. The polish with which he painted ladies' dresses is derived from a study of Dutch genre painting, but, combined with his exceptional abilities as a landscape painter, it gives an entirely original effect. This family, sitting out on their estate, are reminders of a lost world of provincial peace and elegance.

Plate 20. ALLAN RAMSAY (1713–1784): *Lady Robert Manners.* About 1756. Canvas (oval), 74 × 62 cm. London, Tate Gallery (on loan from the National Gallery of Scotland).

Although Ramsay was born in Edinburgh, the son of a Scottish poet, most of his life was spent in London; he also studied extensively in Italy. He inherited his father's intellectual interests and numbered some of the leading minds of the day among his friends. In the early 1760s, he abandoned painting altogether for literary and philosophical pursuits. His mature style is close to that with which Reynolds returned from Italy (Plate 21) and shows great delicacy of technique in the approach to his subjects.

Plate 21. SIR JOSHUA REYNOLDS, P.R.A. (1723–1792): *Lady Chambers*. 1752. Canvas, 70 × 57 cm. London, The Iveagh Bequest, Kenwood.

After studying for a time with the portrait painter, Thomas Hudson (1701–1779), Reynolds went to Italy for four years. On his return, he was rapidly acknowledged as the leading British painter, and was elected first President of the newly formed Royal Academy in 1768. Lady Chambers, wife of the great architect, Sir William Chambers (1726–1796), sat to Reynolds in France on their way back from Italy in 1752, and the result was one of his most sensitive and charming female portraits.

Plate 22. THOMAS GAINSBOROUGH, R.A. (1727–1788): *The Painter's Daughters*. About 1758. Canvas, 114 × 36 cm. London, National Gallery.

Gainsborough painted his daughters, Mary and Margaret, several times during his career, and, like Hogarth with his servants (Plate 17), was not bound by the requirements of his sitters or the conventions of portrait painting when they sat for him. In his early works, they appear in original and adventurous poses. This one is a rarity in his work—indeed in the history of portrait painting—as it shows them in movement, running hand in hand through the countryside after a butterfly. Although unfinished, the exquisite lightness of touch, with glazes of luminous paint may be seen as a halfway development between his early, more detailed style and the brilliant, impressionistic creations of his maturity. This is surely one of the most unaffected and beautiful of all portraits of children.

Plate 23. JOHANN ZOFFANY, R.A. (1733/4–1810): *John Cuff*. Signed and dated 1772. Canvas, 90 × 69 cm. British Royal Collection (reproduced by gracious permission of Her Majesty the Queen).

Zoffany was born in Germany, and in 1760 came to England, where he made a name for himself as a painter of realistic conversation pieces in landscape settings and scenes from plays. The Germanic and sober-minded George III, for whom he did a number of portraits in the 1770s, admired the exact likenesses Zoffany was able to produce, and probably commissioned or bought this painting from the artist. Zoffany's work always has a hard, realistic and thus rather un-English quality; and this subject, with the rugged faces of the London optician, John Cuff, and his assistant and the multitude of tools, pots and wooden surfaces, gave him ample room for his talents.

Plate 24. FRANCIS WHEATLEY, R.A. (1747–1801): *Arthur Phillip* (1738–1814). Signed and dated 1786. Canvas, 91 × 69 cm. London, National Portrait Gallery.

Wheatley carried on the tradition of Devis (Plate 19) and Zoffany (Plate 23) in his small-scale portraits in landscape settings. One of the most versatile artists of his period, his output includes rustic landscapes, sentimental genre, which he learnt from French painters such as Greuze, and the increasingly popular historical subjects. He is still well-known internationally for his series of *The Cries of London* (1793), one of the many sets of engravings issued after his work. Arthur Phillip was the first governor of New South Wales and Wheatley's portrait anticipates his landing in Australia.

Plate 25. GEORGE STUBBS, A.R.A. (1724–1806): *Sir John Nelthorpe out shooting*. Signed and dated 1776. Panel, 61 × 71 cm. English Private Collection.

At the time of this portrait, Stubbs was working on his *Anatomy of the Horse*, for which he had spent eighteen months heroically dissecting putrefying horse carcasses, and he was well qualified to be the greatest sporting painter in an English tradition which began with Seymour and Wootton. His abilities as a landscape and portrait painter, however, are not so widely appreciated. This painting of a country

gentleman out shooting with his dogs reveals Stubbs as a master of composition and of disinterested and scientific observation of all aspects of nature.

Plate 26. JOHN SINGLETON COPLEY, R.A. (1738–1815): *The youngest daughters of George III* (detail). Signed and dated 1785. Canvas, 265 × 186 cm. British Royal Collection (reproduced by gracious permission of Her Majesty the Queen).

Copley was born in Boston and came to England in 1774. He became known for his large historical paintings and attracted the attention of the Royal family, but received little patronage from them. Copley had a rather hard but elegant style and was fond of elaborate compositions, traits which can be seen to good advantage in this portrait of the princesses. The rather 'stagey' effect of the complex poses is heightened by the use of many props such as dogs, parrots and trailing grape vines. According to contemporary accounts, the children, dogs and parrots grew 'equally wearied' of posing and the impatient king had to be pacified by Benjamin West (1738–1820: Reynolds's successor in the Academy).

Plate 27. THOMAS GAINSBOROUGH, R.A. (1727–1788): *The Duke and Duchess of Cumberland* (detail). About 1785–8. Canvas, 164 × 124 cm. British Royal Collection (reproduced by gracious permission of Her Majesty the Queen).

By the time Gainsborough had settled in London in 1774, he had fully evolved his mature style. The tight, confident and distinctive realism of his early landscapes with their doll-like figures had developed into hazy evocations of an ideal English arcadia, peopled with dreamy, elegant beings. The portraits of this later period are usually life-size and this scene of the wayward Duke of Cumberland (1745–1790), the youngest brother of George III, and his wife, walking in a park with their dog, is an unusual reversion to the format of his early work. The graceful world through which the royal pair imperceptibly move seems far removed from the sordid scandals which surrounded their lives; yet Gainsborough allows us to read in their faces the characters concealed behind the elegant façade.

Plate 28. SIR JOSHUA REYNOLDS, P.R.A. (1723–1792): *Georgiana, Duchess of Devonshire* (1757–1806) *and her daughter*. 1784–6. Canvas, 113 × 140 cm. Chatsworth, Trustees of the Chatsworth Settlement.

Reynolds was an educated and ambitious man who wrote intelligently about art and numbered the leading minds in England among his acquaintances. Although, through the demands on his abilities as a portrait painter and the limitations of his talents, he was never able to fulfil his ambition to become a historical painter, he endeavoured to compensate for this failure by making his portraits as visually ambitious as possible. This at times may take the form of endowing his sitters with symbolical and classical attributes, but here he is content with an elaborate baroque composition, full of joie-de-vivre and movement.

Plate 29. JOSEPH WRIGHT of Derby, A.R.A. (1734–1797): *Sir Brooke Boothby* (1744–1824). Signed and dated 1781. Canvas, 148 × 206 cm. London, Tate Gallery.

Joseph Wright received the nickname of 'Wright of Derby' after the town where he was born and spent most of his life. A very competent portrait painter, he also excelled in pictures painted by candle-light and in romantic landscapes. He took a keen interest in industrial and scientific advances and moved in the Midlands in the intellectual circles of which Sir Brooke Boothby was a member. Boothby is seen holding a copy of one of Jean-Jacques Rousseau's *Dialogues* which the French philosopher had entrusted to him to publish in England. Rousseau's cry of 'Back

to nature' is reflected in Boothby's pose: he is depicted reclining meditatively—if somewhat self-consciously—in a woodland landscape which breathes warmth and peace.

Plate 30. GEORGE ROMNEY (1734–1802): *'The Parson's Daughter'*. About 1785. Canvas, diameter 64 cm. London, Tate Gallery.

Romney was born in Kendal in the Lake District and when he came to London soon attracted a large number of fashionable sitters with his fluent and flattering style. His London success quickly developed into an almost hostile rivalry with Reynolds, and for that reason Romney never exhibited at the Royal Academy. The notorious Emma Hamilton, with her attractive but characterless features, was Romney's favourite subject and in the 1780s he painted the many portraits of her in contrived poses for which he is best known today. This study of an unknown lady (perhaps Mrs Pope, a celebrated actress of the day) has for some time been known as 'The Parson's Daughter' and in reproduction was a popular favourite with the Victorians. It is one of his least affected female portraits.

Plate 31. THOMAS GAINSBOROUGH, R.A. (1727–1788): *Lady Bate-Dudley* (detail). 1787. Canvas, 221 × 145 cm. Birmingham, City Art Gallery (on loan from the Burton family).

From a study of Van Dyck (Plates 9 and 10), Gainsborough had learnt both his brilliance of technique and how to impart elegance to his sitters. His lightness and sketchiness of touch, however, are a long way from the work of the Flemish master. Lady Bate-Dudley is seen in a reflective and classicizing mood, leaning on a column—a fashionable pose that Gainsborough borrowed from Reynolds's and Francis Cotes's (1725–1770) grand portraits of the 1770s. Gainsborough had none of Reynolds's intellectual pretensions, however, and, instead of draping his sitter in classical robes, shows her in the exquisite silks and gauzes of contemporary costume which provided a far better subject for his breath-taking brushwork and colour.

The great era of British portrait-painting went out in a blaze of glory with the dazzling virtuosity of the Regency painter, Sir Thomas Lawrence (Plate 33). The wayward Prince Regent (later George IV) was a keen, if undependable, patron of the arts, and it was through his agency that Lawrence's series of portraits of the military heroes and statesmen of the Napoleonic Wars was painted for the Waterloo Chamber at Windsor Castle. Lawrence's only rivals were the short-lived John Hoppner (1758–1810) and John Opie (1761–1807), while Sir William Beechey (Plate 32) offered a staid and less expensive alternative. Scotland was enjoying a golden age, and Sir Henry Raeburn (Plate 34) produced eye-catching and elegant portraits of the prosperous citizens of Edinburgh.

These were less settled times, however, with the French Revolution and wars abroad, the movement for Reform and an unreliable monarchy at home. The Romantic Movement, a product of these times, produced few great portrait painters in any country. Artists such as Turner (1775–1851) and Constable (Plate 36) looked to the natural world for their inspiration, while others such as Wilkie (Plate 35) looked to the past and the heroic deeds of the present. A comparison of the elegantly evocative portraits of the Duke of Wellington by Lawrence and the ruthless analysis of the same man by Goya (London, National Gallery) shows how far Lawrence was from being a genuinely romantic painter of any depth. Instead, we must look to the occasional portraits by artists who specialized in other fields of art for examples of the romantic portrait at its most interesting. Among these would be the searching self-portrait by Etty (Plate 37) and Constable's tender record of his long-suffering fiancée (Plate 36).

Plate 32. SIR WILLIAM BEECHEY, R.A. (1753–1839). *Horatio Lord Nelson* (1758–1805). 1800/1. Canvas, 62 × 48 cm. London, National Portrait Gallery (on loan from the Leggatt Trustees).

Beechey first worked in a lawyer's office but took to painting in 1772. He modelled his style on Reynolds's but brings a romantic flair to his best portraits. This study of the great naval commander is unique in his work for its great spontaneity. A sketch made from life for a whole-length portrait, it has a great feeling of immediacy, emphasized by the clearly visible alterations made while he was at work. The heroic aura which Nelson clearly conjured up is better caught here than in any other portrait of him.

Plate 33. SIR THOMAS LAWRENCE, P.R.A. (1769–1830): *Viscount Castlereagh.* 1810. Canvas, 74 × 62 cm. London, National Portrait Gallery.

A child prodigy, Lawrence established himself with Royal patronage at an early age and soon became the leading portrait painter of his day. He was the only one to be known internationally in his lifetime, and his sitters included almost all the British Establishment and Royalty throughout Europe. Lawrence was a master of the rich, dark oil colours of the early romantic period and had an exceptionally brilliant technique, which was quickly imitated by many lesser painters. The sparkling brushwork and glowing colours do not dominate the character of the intelligent politician. Although Lawrence's portraits are at times little more than virtuoso pieces of brushwork, this one of Lord Castlereagh shows him at his best.

Plate 34. SIR HENRY RAEBURN, R.A. (1756–1823): *Lady Dalrymple.* About 1794. Canvas, 74 × 61 cm. London, Tate Gallery.

Like his only comparable Scottish predecessor, Allan Ramsay (Plate 20), Raeburn studied in Italy; but by the time he had returned to Edinburgh in 1787, the city had entered on a new period of prosperity and he was never forced to move to London to seek patronage. His technically brilliant style, with its forceful, angular brush-stroke, quickly found favour in his native country. Nearly all his leading compatriots, with the exception of Burns, sat to him. Although he did not have Reynolds's or Lawrence's flair for composition (Plates 28 and 33), Raeburn brought a freshness and a certain limpid Scottish light to his elegant and evocative portraits.

Plate 35. SIR DAVID WILKIE, R.A. (1785–1841): *Frederick, Duke of York* (1763–1827). 1823. Panel, 59 × 52 cm. London, National Portrait Gallery.

Born in Scotland, Wilkie worked in London nearly all his life. He became the leading exponent of genre painting, including scenes from peasant life in the Dutch style and records of contemporary events. He was much employed by the Royal family and was made Painter in Ordinary by George IV. His portraits are notable for their informality and characterization. Frederick, the 'grand old' Duke of York, is here depicted in his study reading dispatches while his dog lies patiently under the table.

Plate 36. JOHN CONSTABLE, R.A. (1776–1837): *Maria Bicknell (later Mrs Constable).* 1816. Canvas, 45 × 25 cm. London, Tate Gallery.

Although Constable is universally known as one of the greatest of all landscape painters, at the beginning of his career he was obliged through economic circumstances to paint portraits, mostly of the gentry of his native East Bergholt. Few of them give any indication of his future promise. As with his landscapes, Constable needed to know and love his subject, and on rare occasions, such as in this portrait of his fiancée, with whom he had had a protracted engagement for five years, his full genius can be seen.

Plate 37. WILLIAM ETTY, R.A. (1787–1849): *Self-Portrait.* 1825. Panel, 42 × 32 cm. Manchester, City Art Gallery.

William Etty is best known for his lush paintings of nudes—a hybrid mixture of neo-classical subjects painted in a dashing, romantic style which he learnt from Lawrence (Plate 33). The classical/romantic contradiction of his subject pictures is echoed in the form of the self-portrait, which is that of a Roman profile cameo. The treatment however is rich, dark and romantic, reminiscent of the works of contemporary French painters such as Delacroix. While Etty did not have the education or imagination of a great artist, he was very much a man of his age, and reveals himself here as an introspective personality. Against the dark background, the shadowed face is brought to life by the virtuoso painting and bright, pure colours of the collar and cravat.

The history of portrait painting in Victorian England was affected by a number of factors. Not the least important was that between the death of Lawrence in 1830 and the emergence of Sargent (see Plate 44) in the mid-1880s, there was no portraitist capable of providing the age with a commanding image of itself; and because there was no supreme figure to set the pace and provide guide lines, the development of portraiture is haphazard. There was also the development of photography. From the early 1840s onwards, the photograph totally undermined the basic aim of the drawn or painted portrait.

One social side-effect of photography was that, since the painting of one's portrait was no longer technically necessary, it became even more of a status symbol than ever before. Also, since it was no longer associated in the public mind with the drudgery of a quick commercial operation, portrait painting was an activity that even the grandest of history or landscape painters could take up without loss of prestige. Painters with a reputation in other genres, like Millais (see Plate 40), Holl, Fildes, Herkomer or Watts (see Plate 39), also took up portraiture because there was never any problem about disposing of a finished work at a price commensurate with their reputation. Partly because the type of person who commissioned a portrait in, say, 1875, tended to be very conventional, partly because of the low imaginative calibre of the artists at work, and even partly because of the clothes, most Victorian portraits are extremely dull as works of art. It is no accident that many of the more interesting are by artists such as Tissot (Plate 42), Whistler (Plate 41), Sickert (Plate 43) and Alfred Stevens (Plate 38), none of whom were portrait painters as the Victorians would have understood the term.

The actual title of Plate 41 is *Harmony in Grey and Green: Miss Cecily Alexander.* The implications of this juxtaposition, that a portrait, as well as being a likeness, must also be judged from the purely formal point of view as an arrangement of lines and colours, have had an increasing relevance to portrait painting in the last eighty years, as art has been less and less concerned with an accurate representation of the everyday world. In the twentieth century, the development of abstraction has cut off an enormous number of artists from even the possibility of portraiture, and the romantic cult of artistic integrity has made the problem even more difficult than it might otherwise have been. The demands that are made of a portrait painter anxious to become a fashionable artist remain much the same from age to age. The result, in our own day, is that in order to bridge the gulf between *avant-garde* styles and the requirements of a likeness, artists have had to effect serious compromises. In most cases, professional portraiture has fallen into the hands of able painters purveying a conventional style that is nowhere near the centre of sophisticated taste and seldom earns critical plaudits. The average three-quarter-length seated portrait of the local mayor or magnate is typical. With the more experimental kind of artist, portraiture, when they undertake it, is no longer really a matter of business so much as an aesthetic adventure, with sitters, culled

from among friends and the intelligentsia, who are prepared to share in the experiment and who will not judge the results by the standards of a colour photograph. It is no accident that the portraits reproduced here by Sickert, Lamb, Sutherland and Freud, all represent fellow artists and writers.

Plate 38. ALFRED STEVENS (1817–1875): *Mrs Mary Ann Collmann.* 1854. Canvas, 70 × 55 cm. London, Tate Gallery.

Alfred Stevens enjoyed a varied but not altogether successful career. He was active as a sculptor, painter and decorative designer, and his first great success came in 1856, when he won the competition for the memorial to the Duke of Wellington intended for St Paul's Cathedral. Lack of money, government interference and other difficulties worked against him, however, and the monument was not completed in his lifetime. In its depth of observation, pose and sheer quality of painting, this portrait is one of the masterpieces of nineteenth-century British art.

Plate 39. GEORGE FREDERICK WATTS (1817–1904): *Cardinal Manning.* 1882. Canvas, 90 × 70 cm. London, National Portrait Gallery.

Although the theory is less popular now, it was for long held that while an artist should strive to create his own images, a strongly cultivated sense of pictorial tradition would do these newly evolved images no harm. This was particularly true in the case of Watts. The portrait of the famous English Roman Catholic Cardinal, Henry Edward Manning (1808–1892)—the subject of one of Lytton Strachey's brilliant essays in *Eminent Victorians*—was meant to be judged as a likeness of a renowned ecclesiastic. But the artist also wanted it to be appreciated in the context of the great tradition of portraiture going back to Titian, whose own style permeates the design and colouring of the new work.

Plate 40. SIR JOHN EVERETT MILLAIS, P.R.A. (1829–1896): *Portrait of John Ruskin.* Canvas, 79 × 68 cm. Signed and dated 1854. English Private Collection.

In 1848 Millais helped to found the Pre-Raphaelite Brotherhood, which immediately ran into trouble; the novel style of the paintings that he and Holman Hunt exhibited at the Royal Academy created a storm of abuse. John Ruskin was the most influential art critic in Britain and the letters he wrote to *The Times*, in defence of the Pre-Raphaelites, helped to turn the tide in their favour. One of the chief tenets of Pre-Raphaelitism was truth to nature in every particular, and this painting is the most famous, and the most ambitious, attempt to apply these principles to portraiture. The landscape background was painted out of doors, but the figure was painted in the studio.

Plate 41. JAMES MCNEILL WHISTLER (1834–1903): *Harmony in Grey and Green: Miss Cecily Alexander.* About 1872–4. Canvas, 190 × 98 cm. London, Tate Gallery.

Whistler was born in Lowell, Massachusetts. After having failed at West Point Military Academy, and after working for a time as a Navy cartographer, he went to Paris in 1855 to study painting. He was soon moving in *avant-garde* circles, meeting and being influenced by artists such as Degas, Manet and Courbet. A witty man, with a strong theatrical streak, Whistler played the dandy and was always stressing the value of 'art for art's sake' in a milieu in which the man who did not know much about art but knew what he liked was an all too familiar figure. This behaviour might suggest the dilettante, the amateur dabbler; but nothing could be further from the case. The portrait of Miss Alexander, the daughter of an industrialist and patron of Whistler, required seventy sittings.

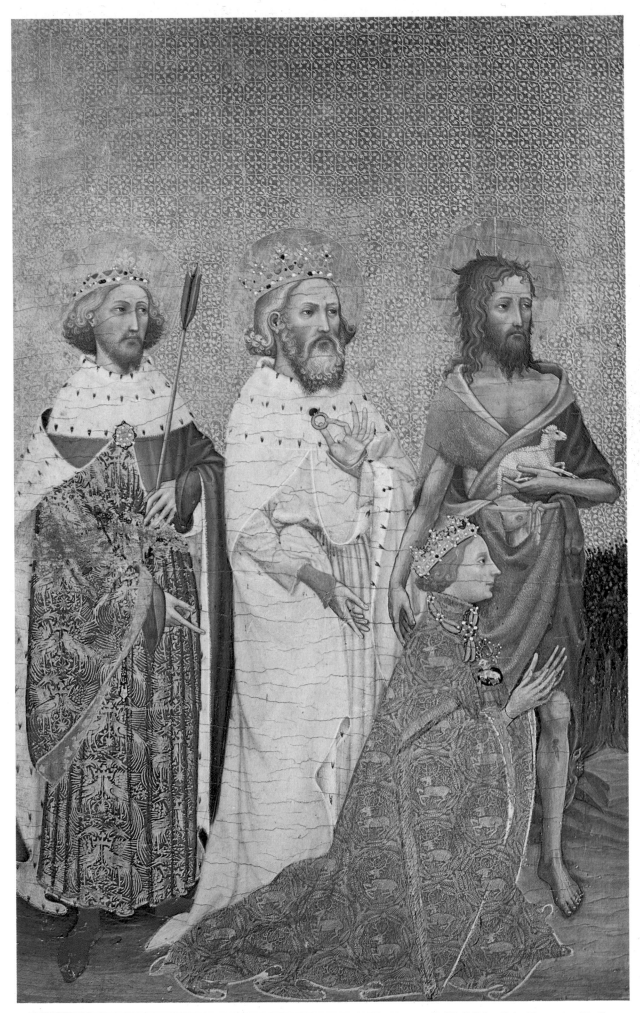

I. UNKNOWN ARTIST: *Richard II presented to the Virgin and Child by his Patron Saints* (left half of the *Wilton Diptych*). About 1395–9. London, National Gallery

2. HANS HOLBEIN THE YOUNGER (1497/98–1543): *Henry VIII*. 1536(?).
Lugano, Thyssen Collection

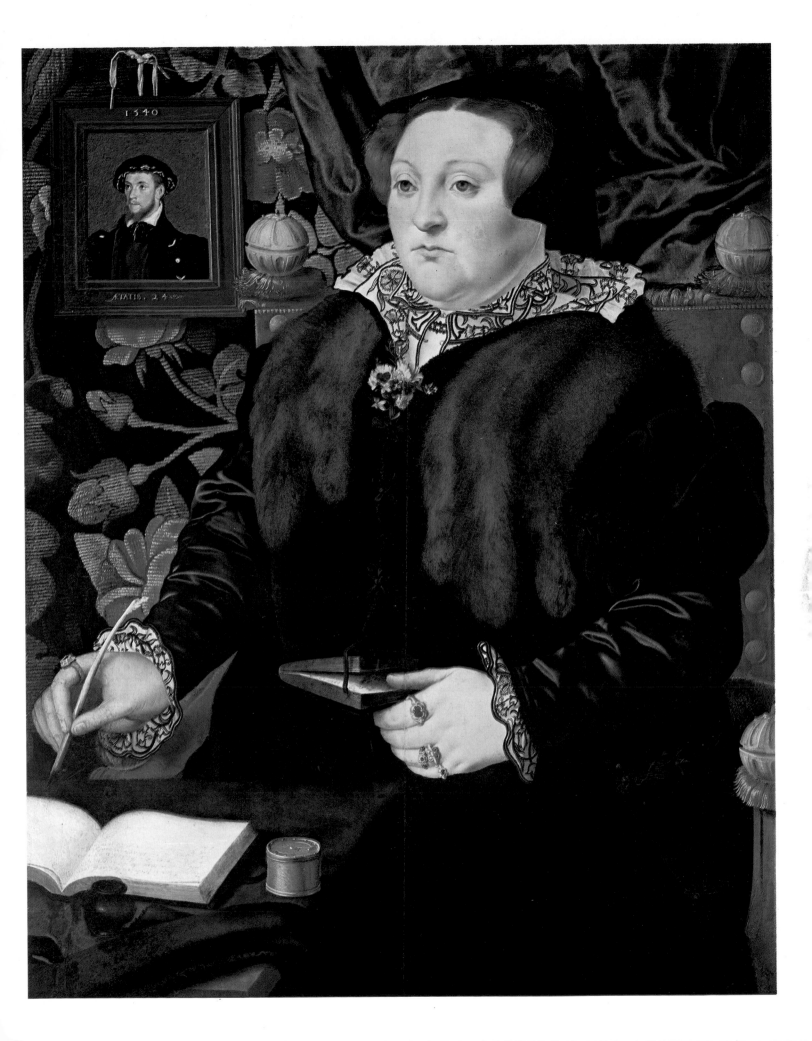

3. HANS EWORTH (active 1540–1574): *Lady Dacre*. About 1555. Ottawa, National Gallery of Canada

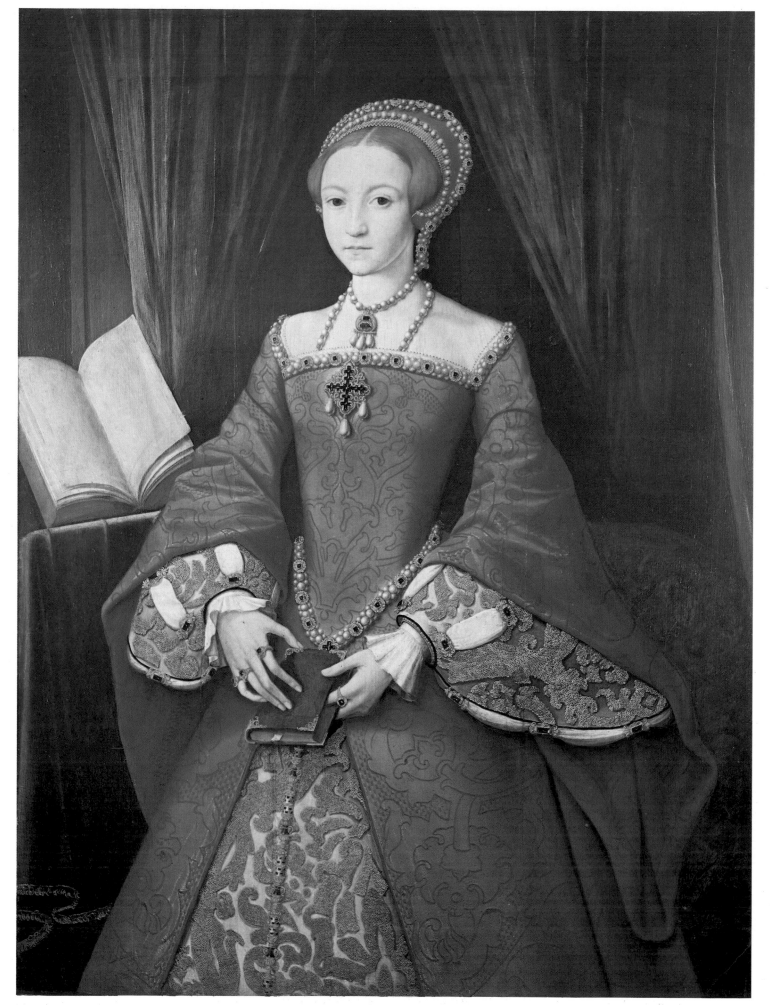

4. UNKNOWN ARTIST: *Elizabeth I when Princess*. About 1546.
British Royal Collection (reproduced by gracious permission of Her Majesty the Queen)

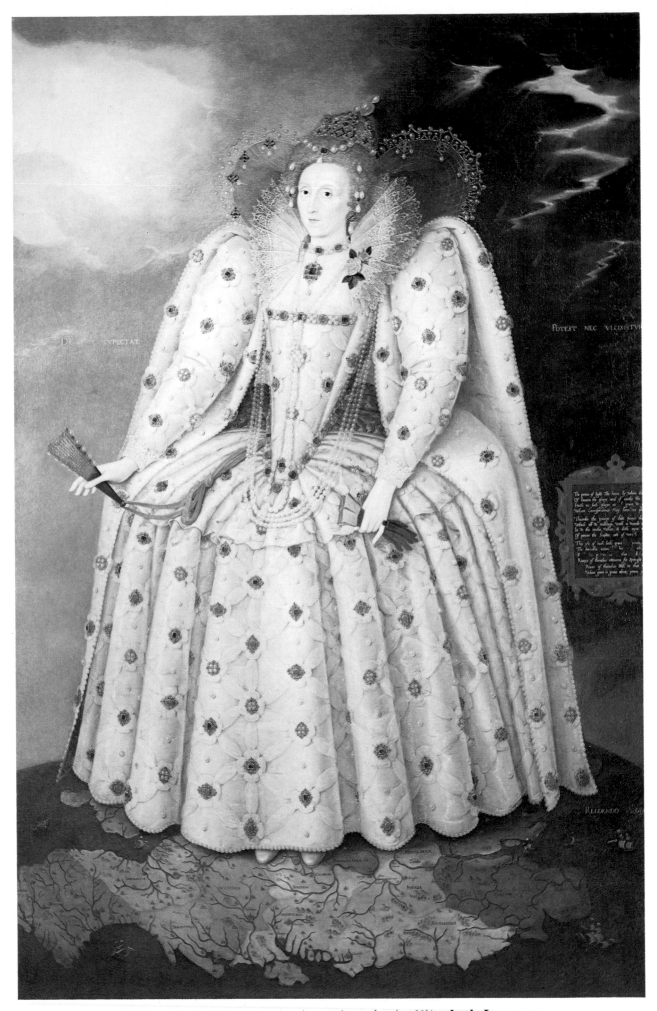

5. MARCUS GHEERAERTS THE YOUNGER (*c.* 1561–1635): *Elizabeth I.* 1592.
London, National Portrait Gallery.

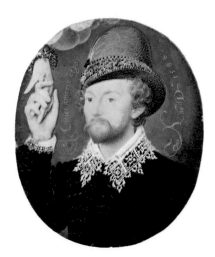

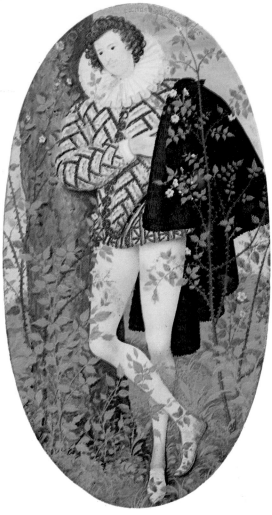

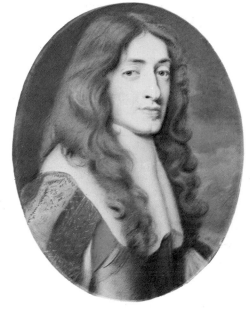

6a. HANS HOLBEIN THE YOUNGER (1497/98–1543): *Mrs Pemberton*. About 1540–3. London, Victoria and Albert Museum. *Top, left*

6b. NICHOLAS HILLIARD (*c.* 1547–1619): *A Young Man*. 1588. London, Victoria and Albert Museum. *Top, right*

6c. SAMUEL COOPER (1609–1672): *James II as Duke of York*. 1661. London, Victoria and Albert Museum. *Left*

6d. NICHOLAS HILLIARD (*c.* 1547–1619): *A youth leaning against a tree among roses*. About 1588. London, Victoria and Albert Museum. *Centre*

7. ISAAC OLIVER (died 1617): *Richard Sackville, 3rd Earl of Dorset*. 1616. London, Victoria and Albert Museum. *Opposite*

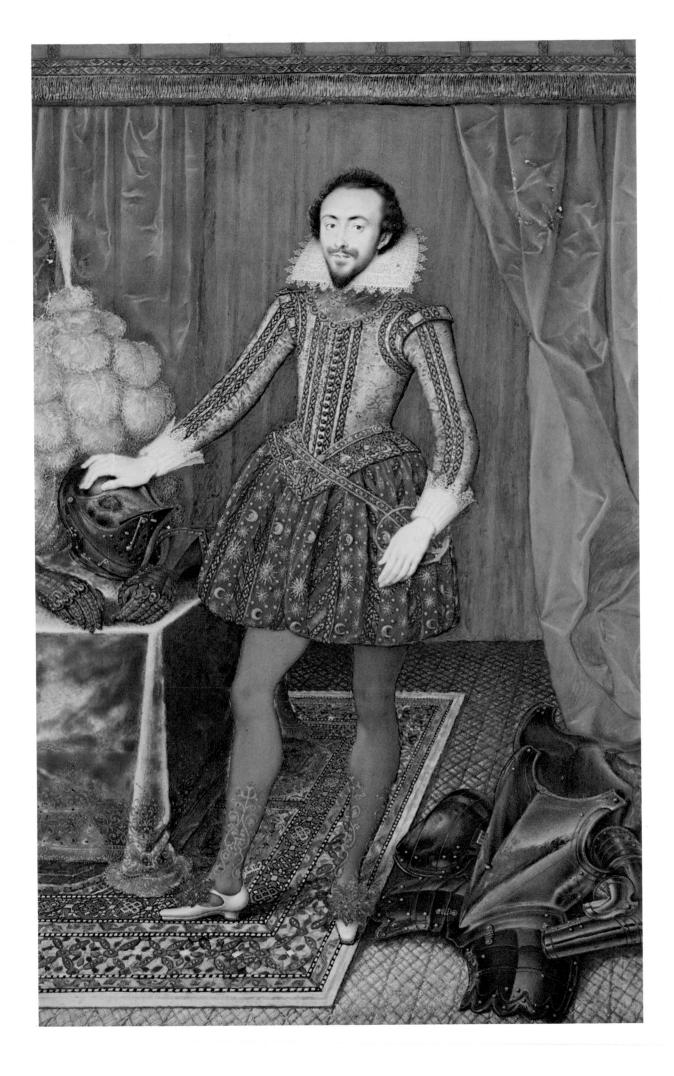

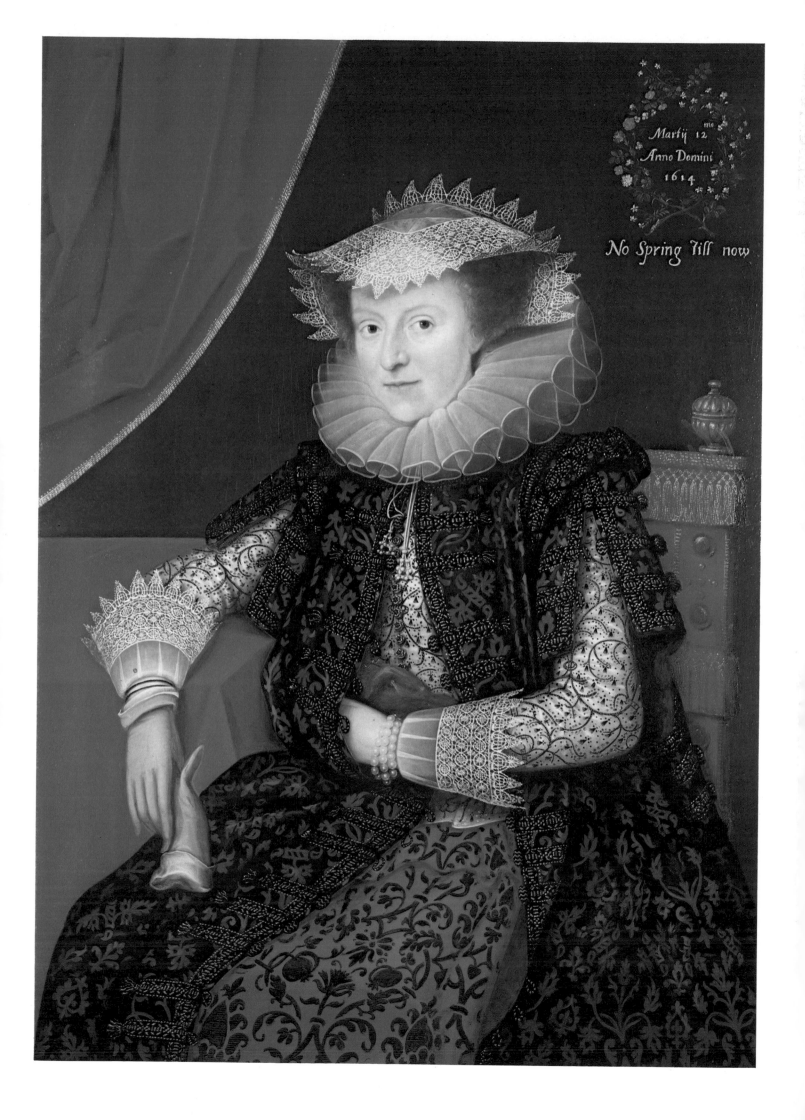

Martij 12
Anno Domini
1614

No Spring Till now

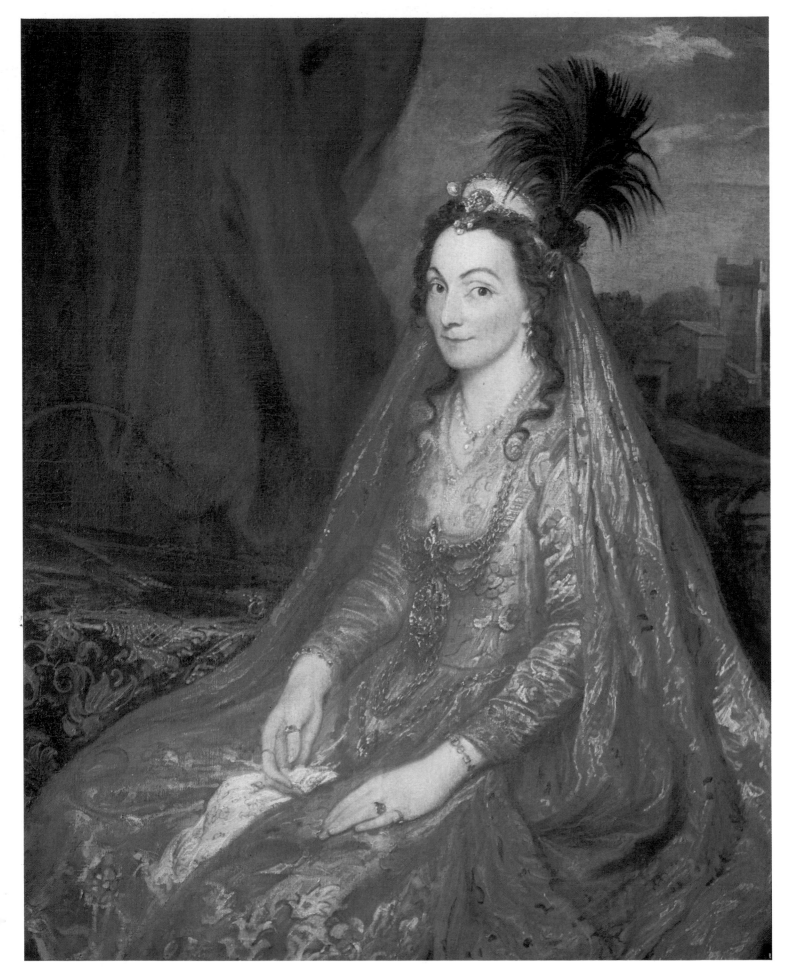

9. SIR ANTHONY VAN DYCK (1599–1641): *Lady Shirley* (detail). 1622. Sussex, Petworth House (National Trust)

8. MARCUS GHEERAERTS THE YOUNGER (*c.* 1561–1635): *Mary Throckmorton, Lady Scudamore.* 1614/15. London, Tate Gallery (on loan from the National Portrait Gallery)

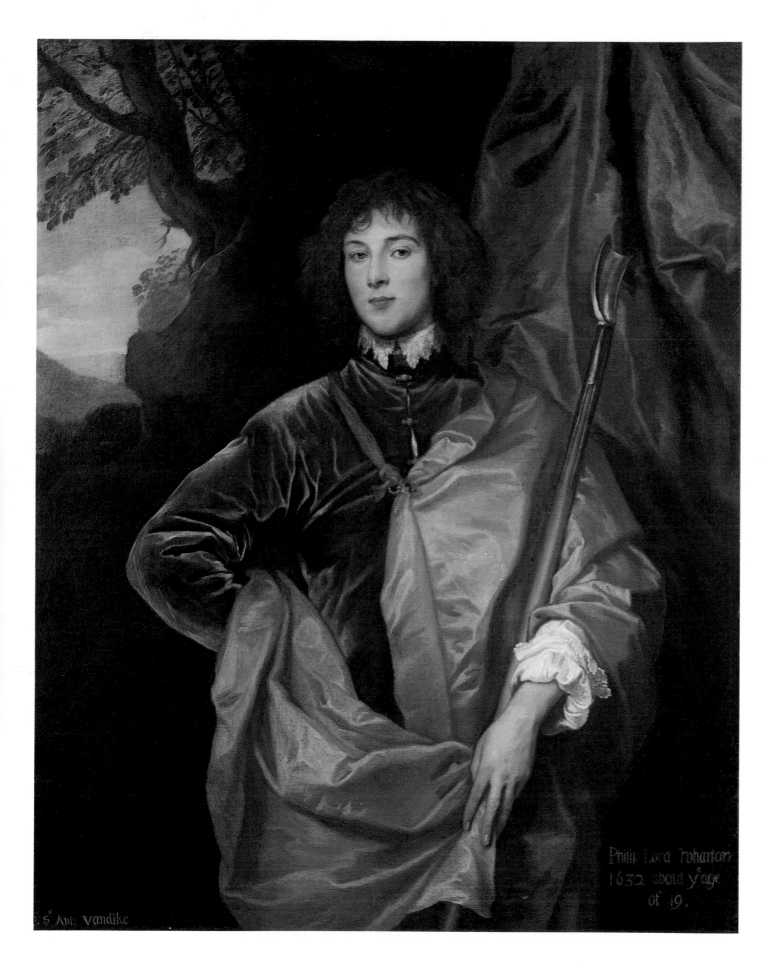

Philip Lord Wharton
1632 about y.º age
of 19.

Sr Ant. Vandike

10. SIR ANTHONY VAN DYCK (1599–1641): *Philip, Lord Wharton.* 1632. Washington, D.C., National Gallery of Art (Mellon Collection)

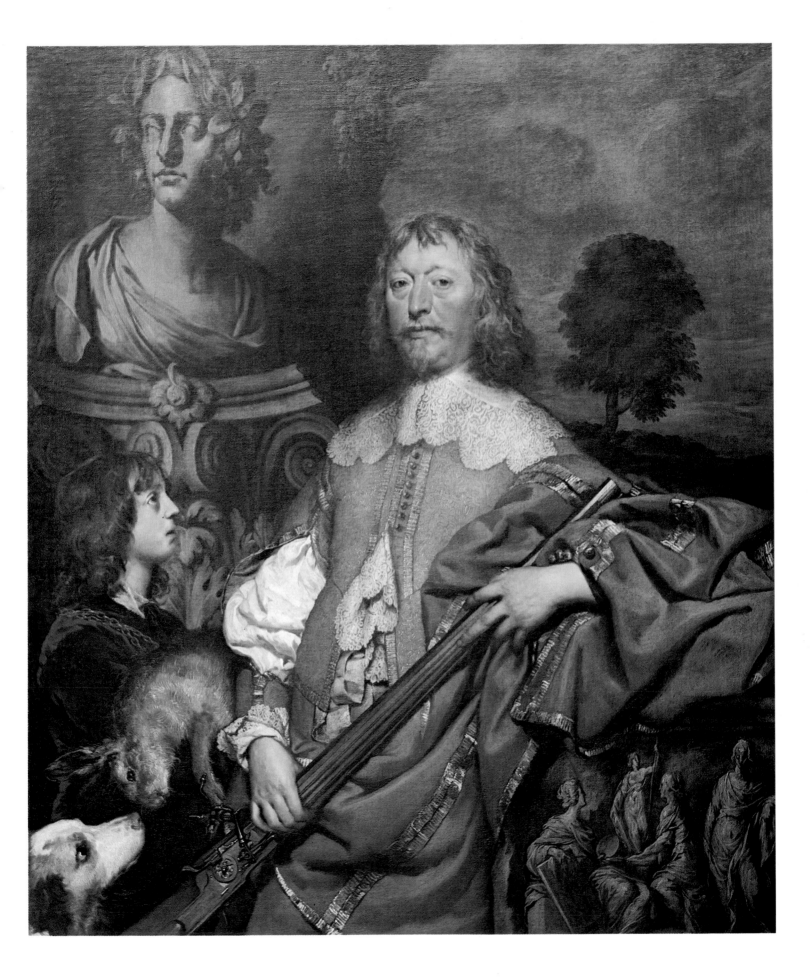

11. WILLIAM DOBSON (1611–1646): *Endymion Porter*. About 1643–5. London, Tate Gallery

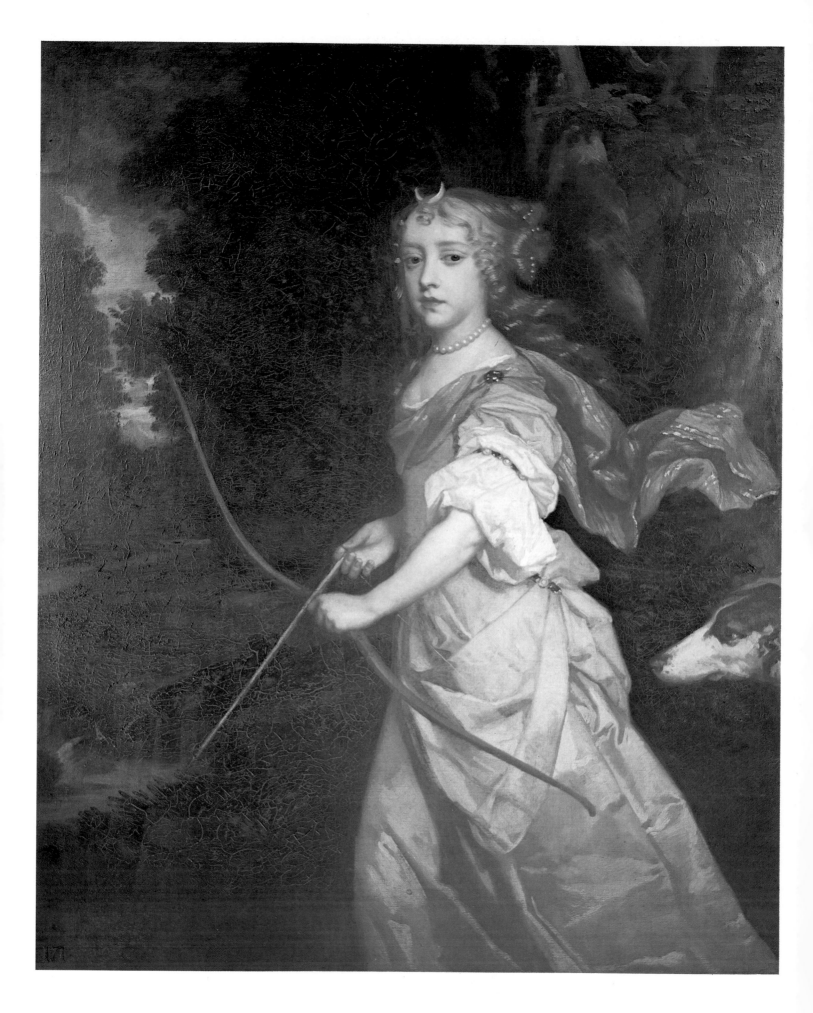

12. SIR PETER LELY (1618–1680): *Mary II when Princess*. About 1672. British Royal Collection
(reproduced by gracious permission of Her Majesty the Queen)

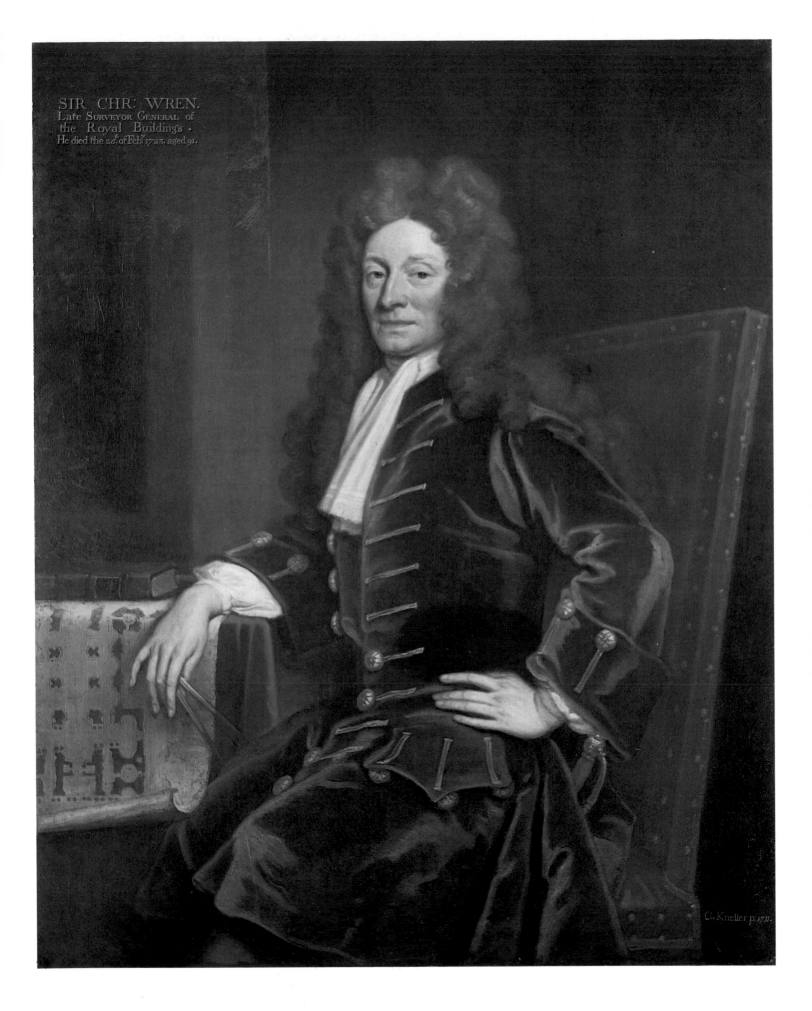

SIR CHR: WREN.
Late Surveyor General of
the Royal Buildings .
He died the 26. of Feb: 1723, aged 91.

C. Kneller p. 1711.

13. SIR GODFREY KNELLER (1646(?)–1723): *Sir Christopher Wren.* 1711.
London, National Portrait Gallery

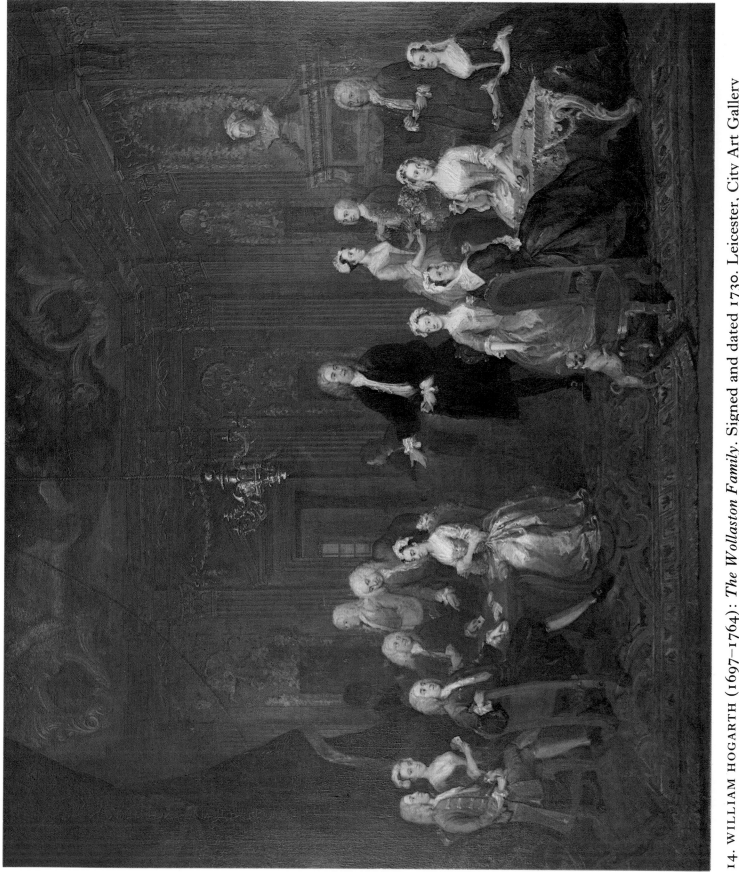

14. WILLIAM HOGARTH (1697–1764): *The Wollaston Family*. Signed and dated 1730. Leicester, City Art Gallery (on loan from the Trustees of the late Mr H. C. Wollaston)

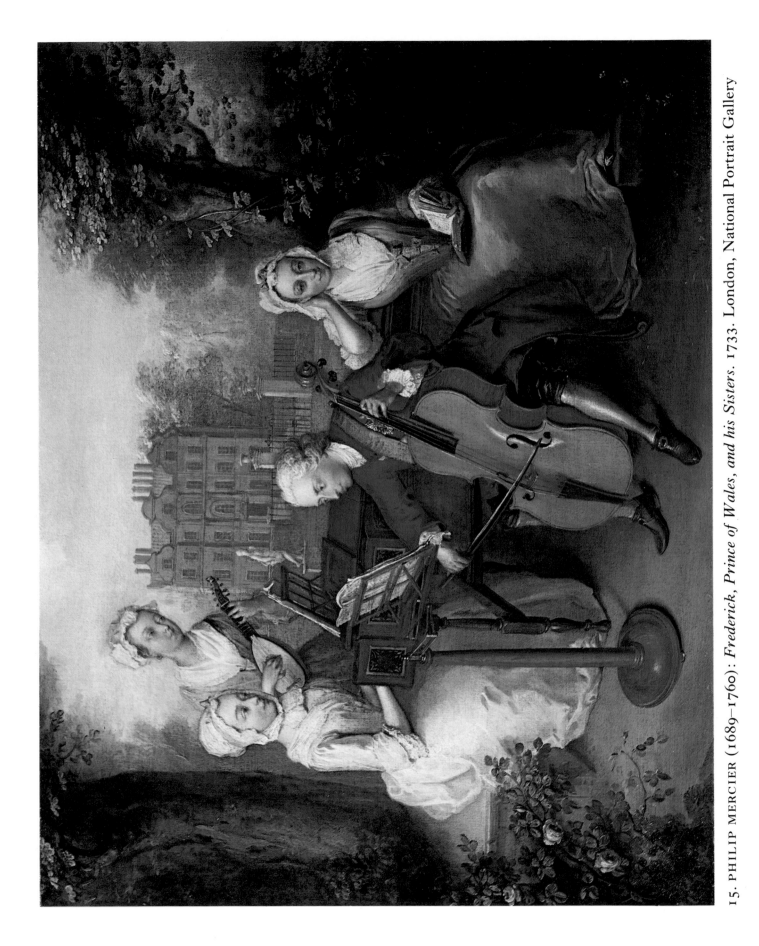

15. PHILIP MERCIER (1689–1760): *Frederick, Prince of Wales, and his Sisters*. 1733. London, National Portrait Gallery

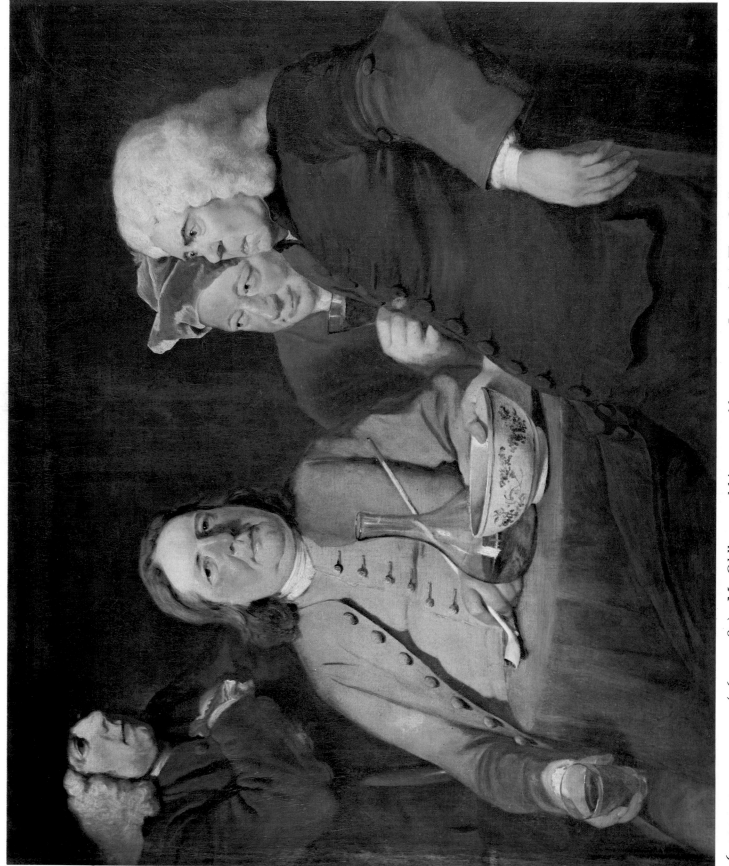

16. JOSEPH HIGHMORE (1692–1780): *Mr Oldham and his guests.* About 1750. London, Tate Gallery

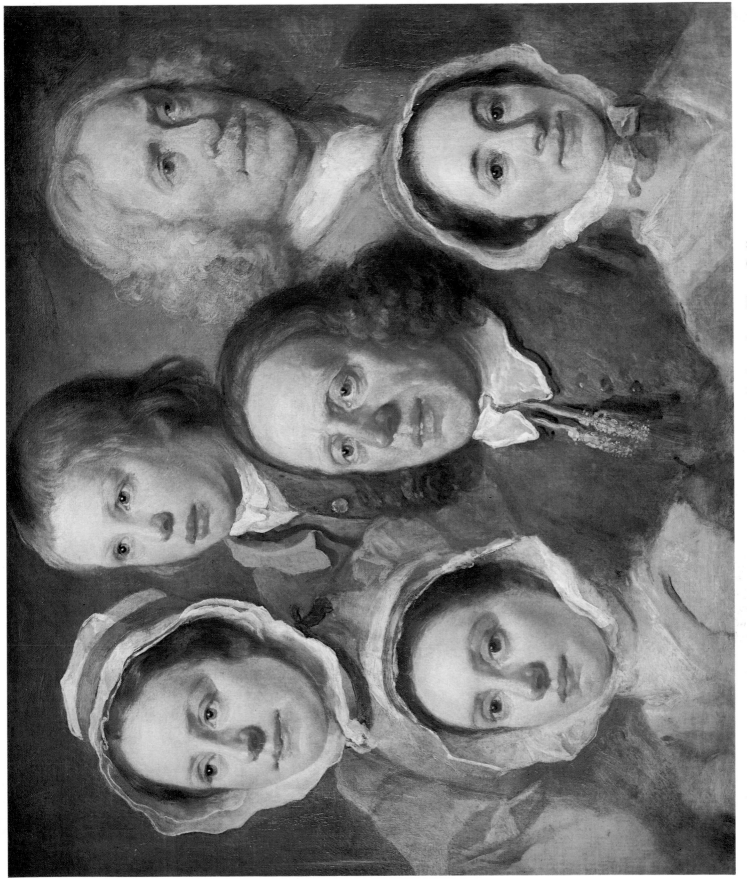

17. WILLIAM HOGARTH (1697–1764): *Hogarth's Servants*. 1745–50(?). London, Tate Gallery

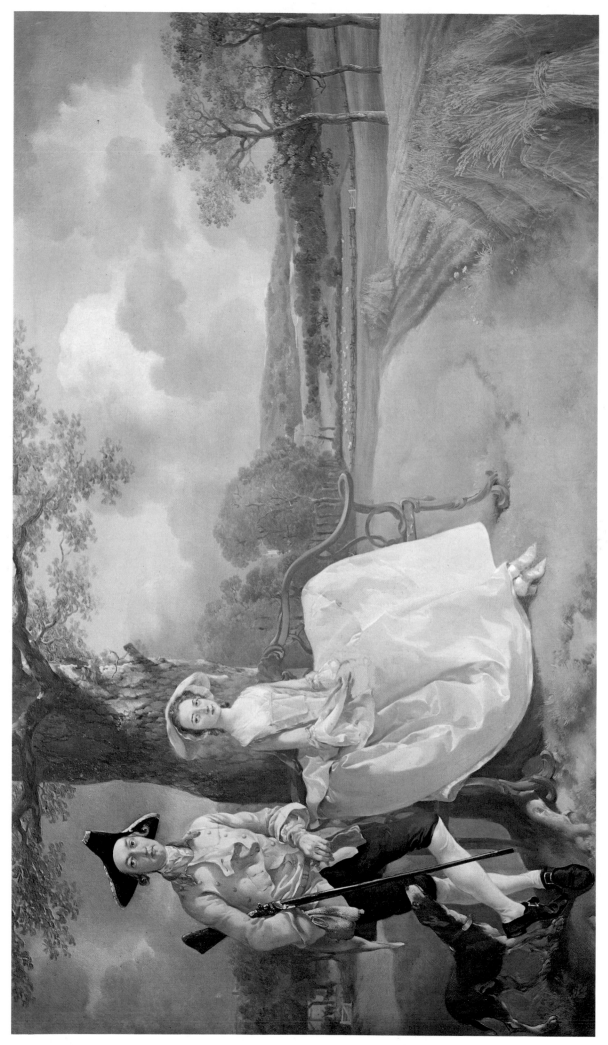

18. THOMAS GAINSBOROUGH, R. A. (1727–1788): *Mr and Mrs Andrews*. About 1750. London, National Gallery

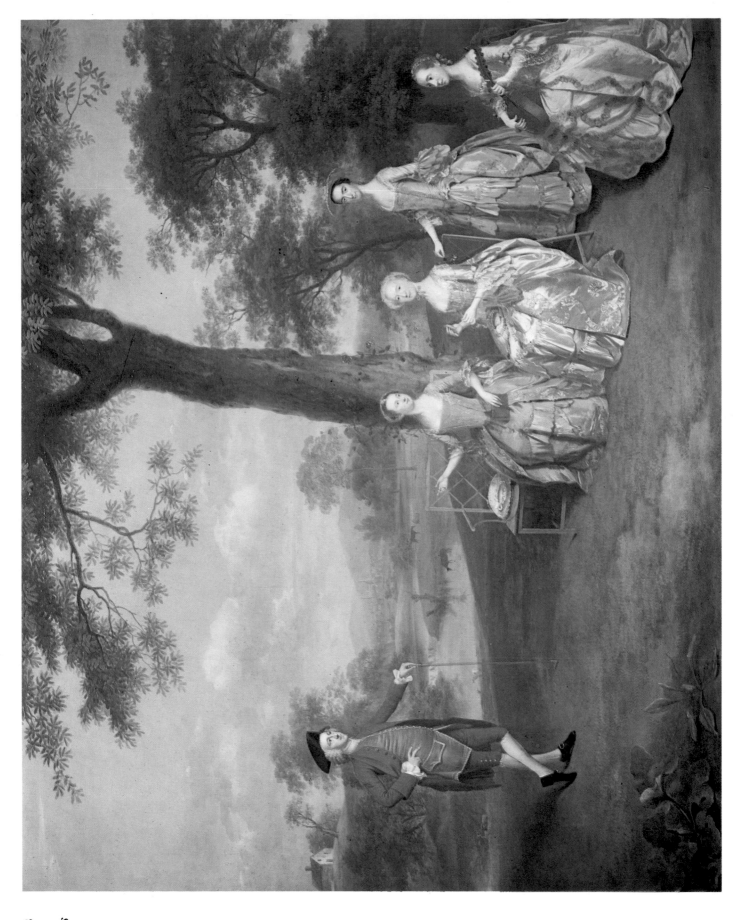

19. ARTHUR DEVIS
(1711–1787):
*Edward Rookes
Leeds and his
family*. About
1760. English
Private
Collection

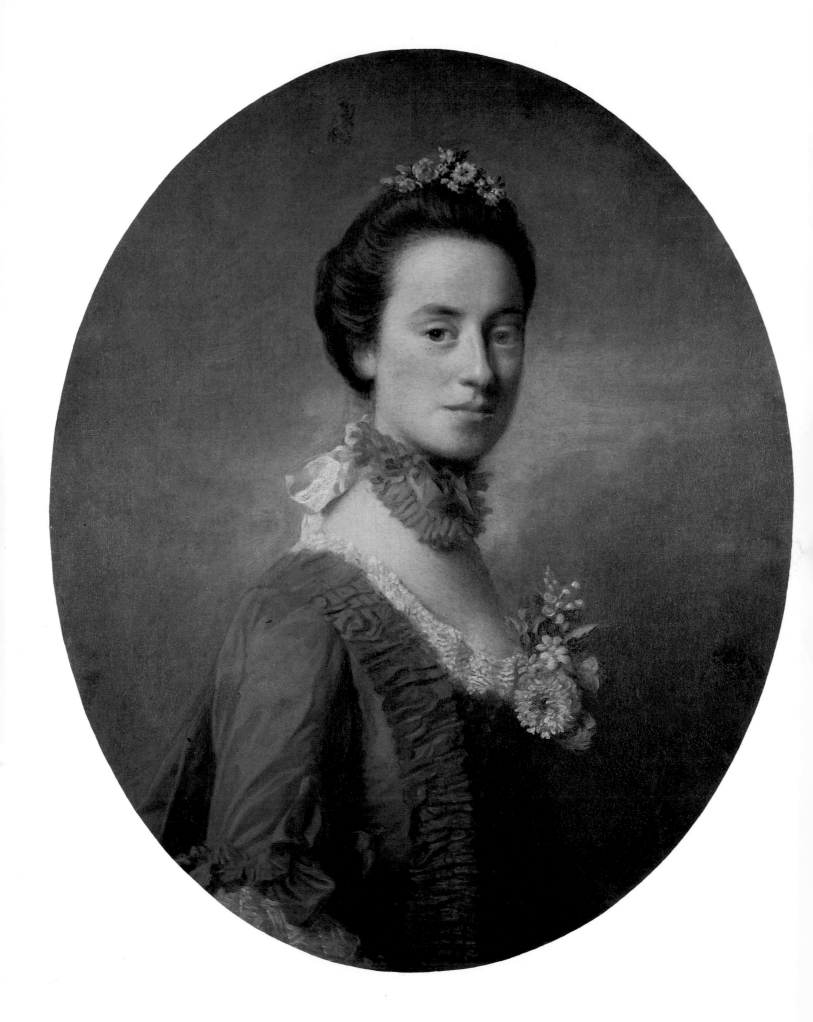

20. ALLAN RAMSAY (1713–1784): *Lady Robert Manners*. About 1756. London, Tate Gallery
(on loan from the National Gallery of Scotland)

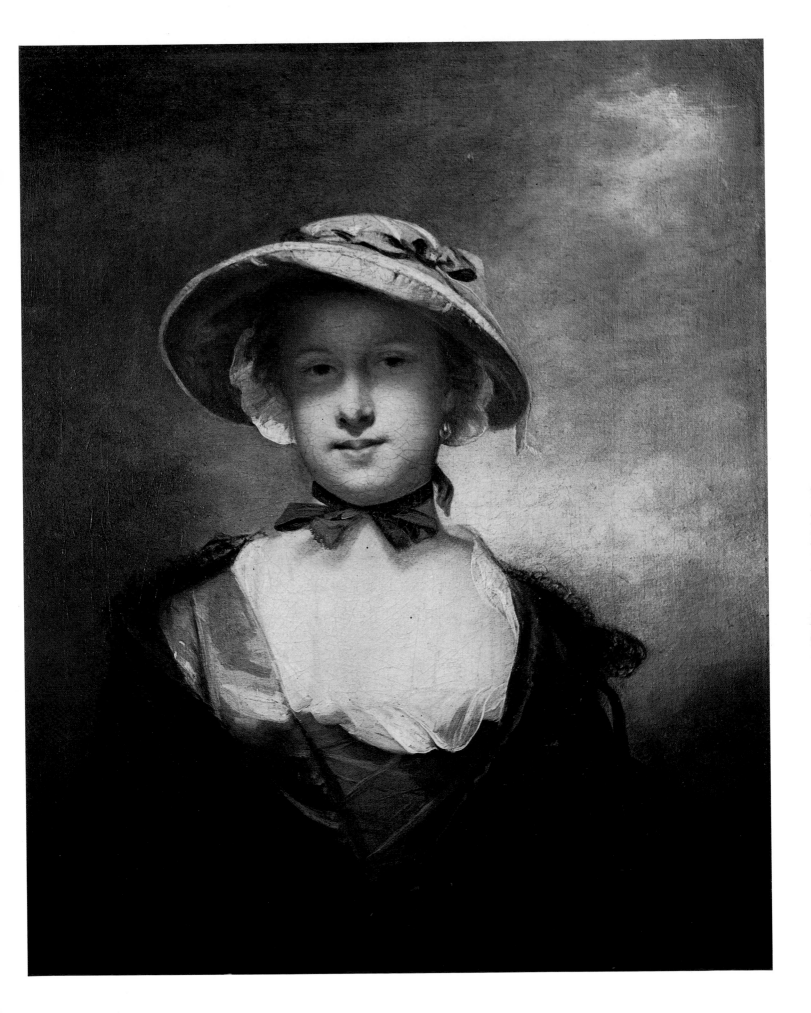

21. SIR JOSHUA REYNOLDS, P.R.A. (1723–1792): *Lady Chambers*. 1752.
London, The Iveagh Bequest, Kenwood

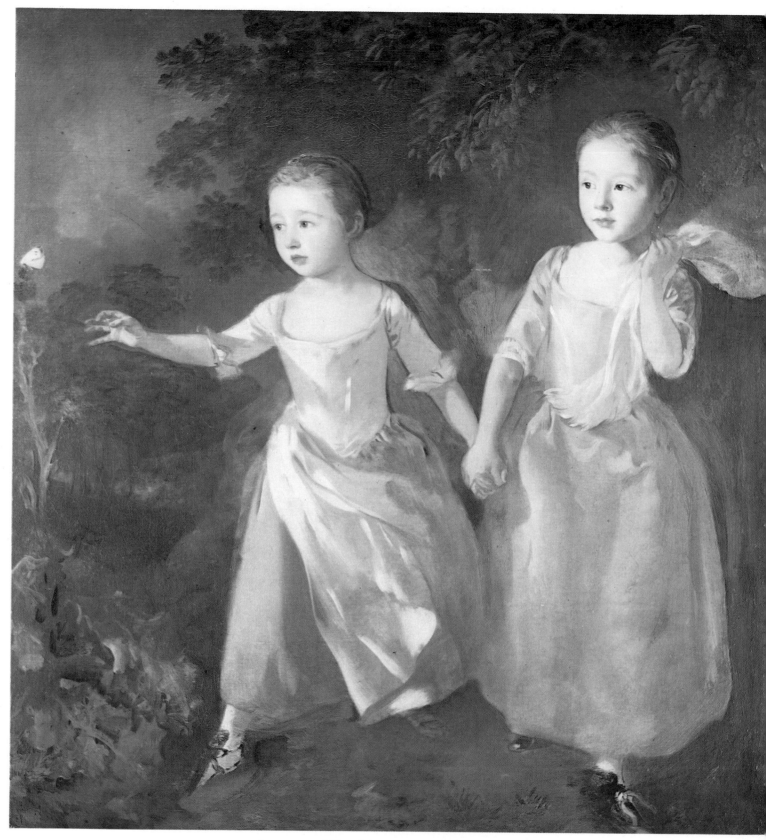

22. THOMAS GAINSBOROUGH, R.A. (1727–1788): *The Painter's Daughters*. About 1758.
London, National Gallery

23. JOHANN ZOFFANY, R.A. (1733/4–1810): *John Cuff*. Signed and dated 1772. British Royal Collection
(reproduced by gracious permission of Her Majesty the Queen)

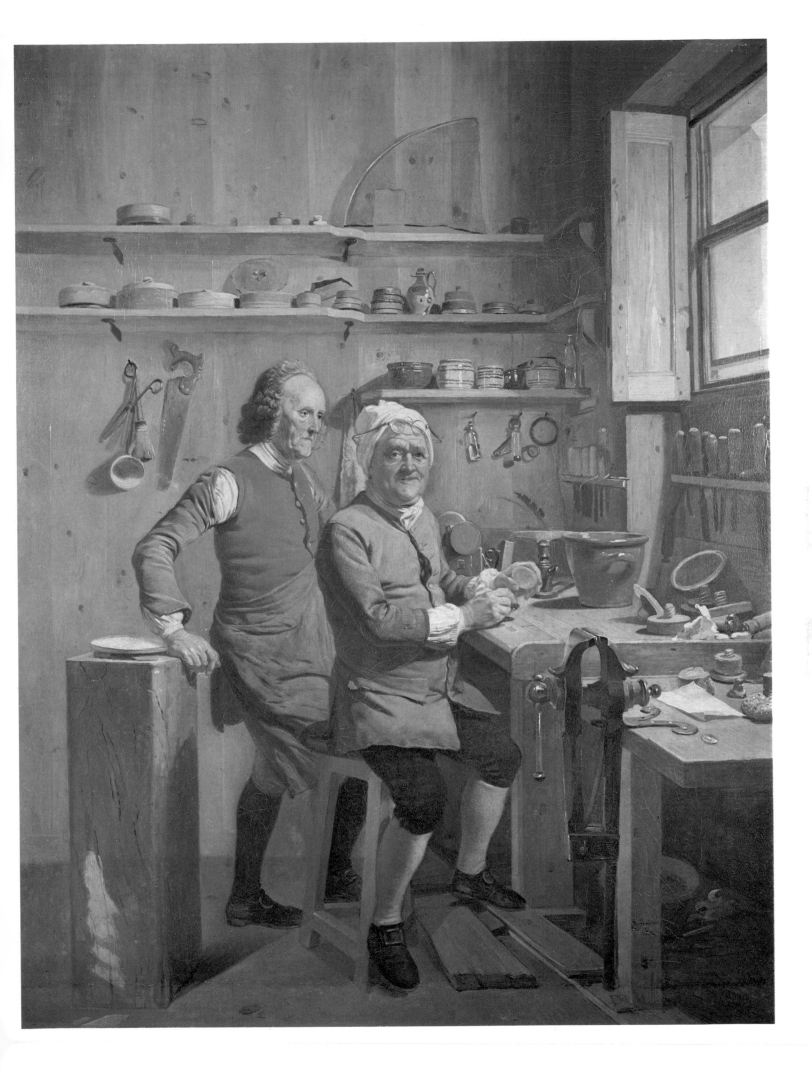

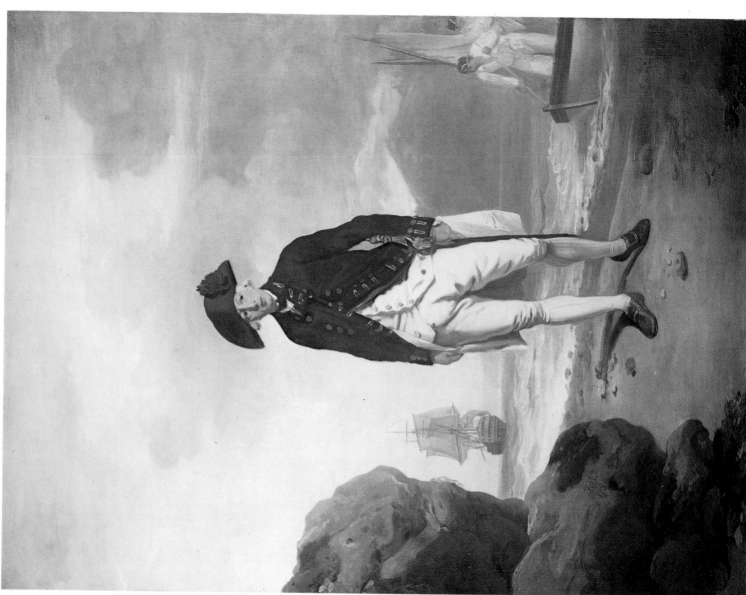

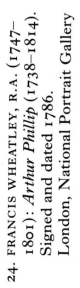

24. FRANCIS WHEATLEY, R.A. (1747–1801): *Arthur Phillip* (1738–1814). Signed and dated 1786. London, National Portrait Gallery

25. GEORGE STUBBS, A.R.A. (1724–1806): *Sir John Nelthorpe out shooting*. Signed and dated 1776. English Private Collection

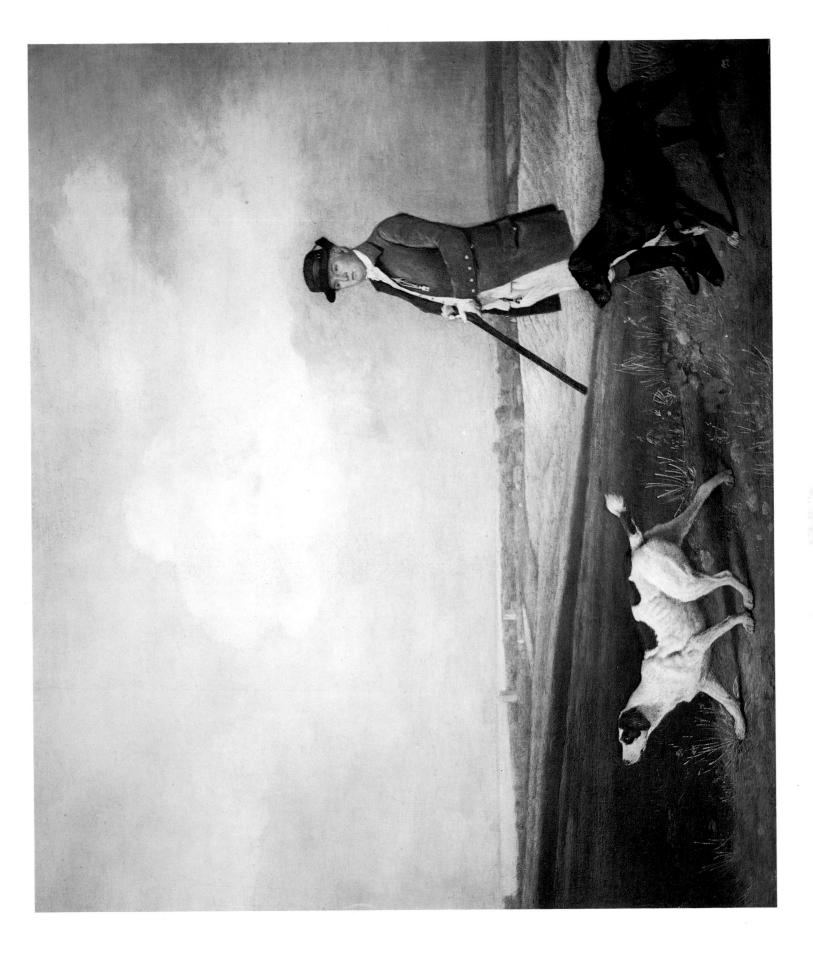

26. JOHN SINGLETON COPLEY, R.A. (1738–1815): *The youngest daughters of George III* (detail).
Signed and dated 1785. British Royal Collection (reproduced by gracious permission
of Her Majesty the Queen)

27. THOMAS GAINSBOROUGH, R.A. (1727–1788): *The Duke and Duchess of Cumberland* (detail).
About 1785–8. British Royal Collection (reproduced by gracious permission
of Her Majesty the Queen)

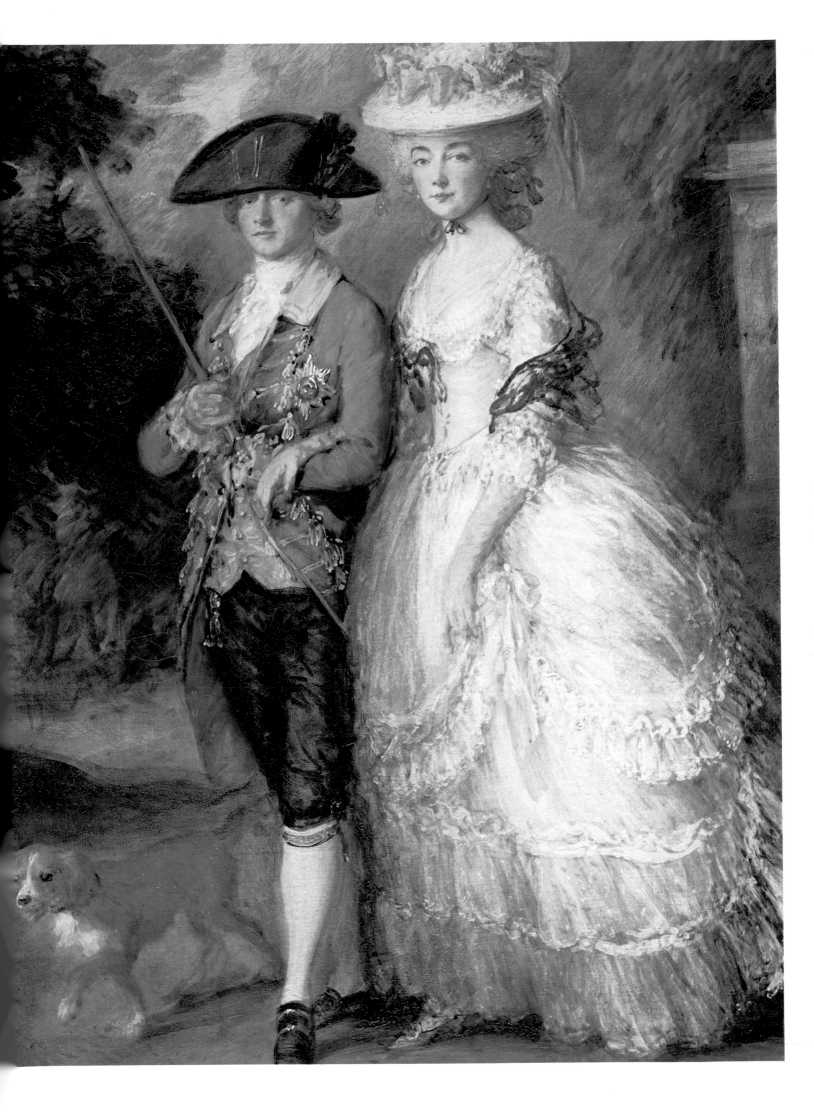

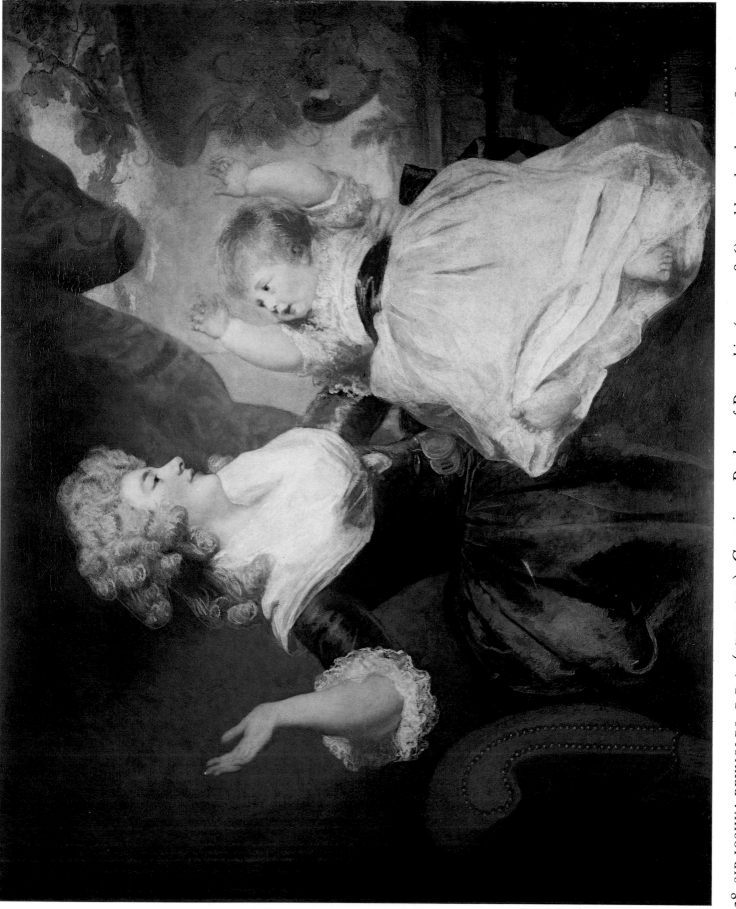

28. SIR JOSHUA REYNOLDS, P.R.A. (1723–1792): *Georgiana, Duchess of Devonshire (1757–1806) and her daughter*. 1784–6. Chatsworth, Trustees of the Chatsworth Settlement

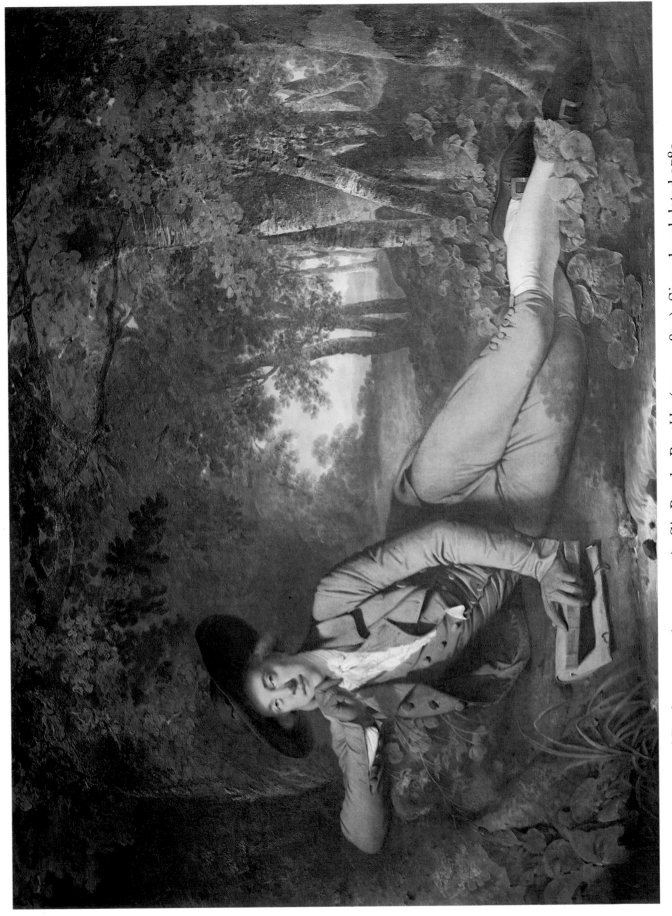

29. JOSEPH WRIGHT of Derby, A.R.A. (1734–1797): *Sir Brooke Boothby* (1744–1824). Signed and dated 1781.
London, Tate Gallery

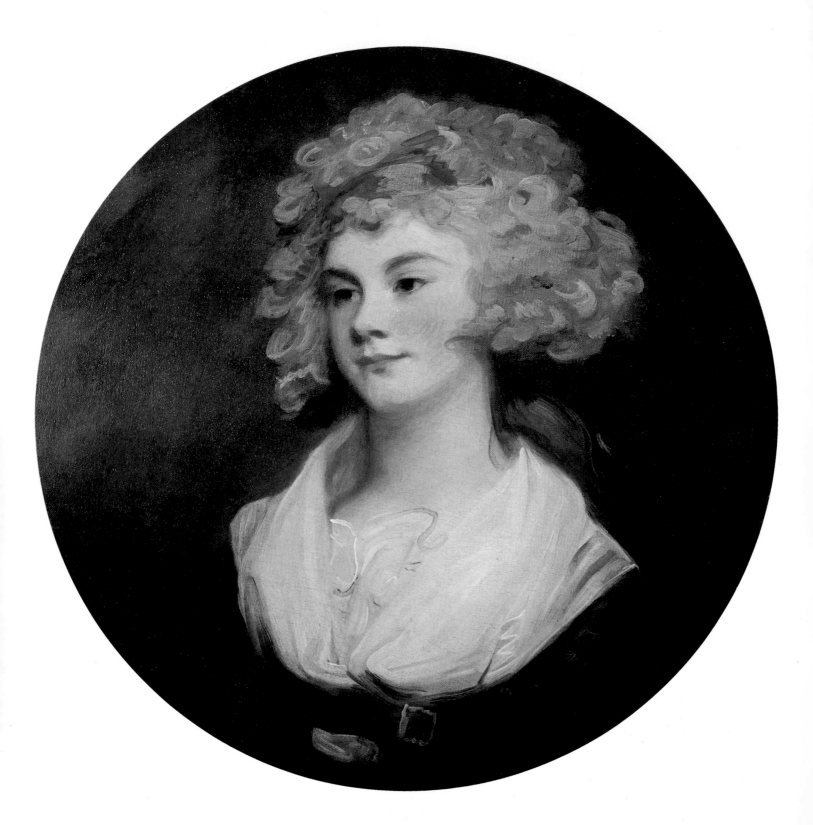

30. GEORGE ROMNEY (1734–1802): '*The Parson's Daughter*'. About 1785. London, Tate Gallery

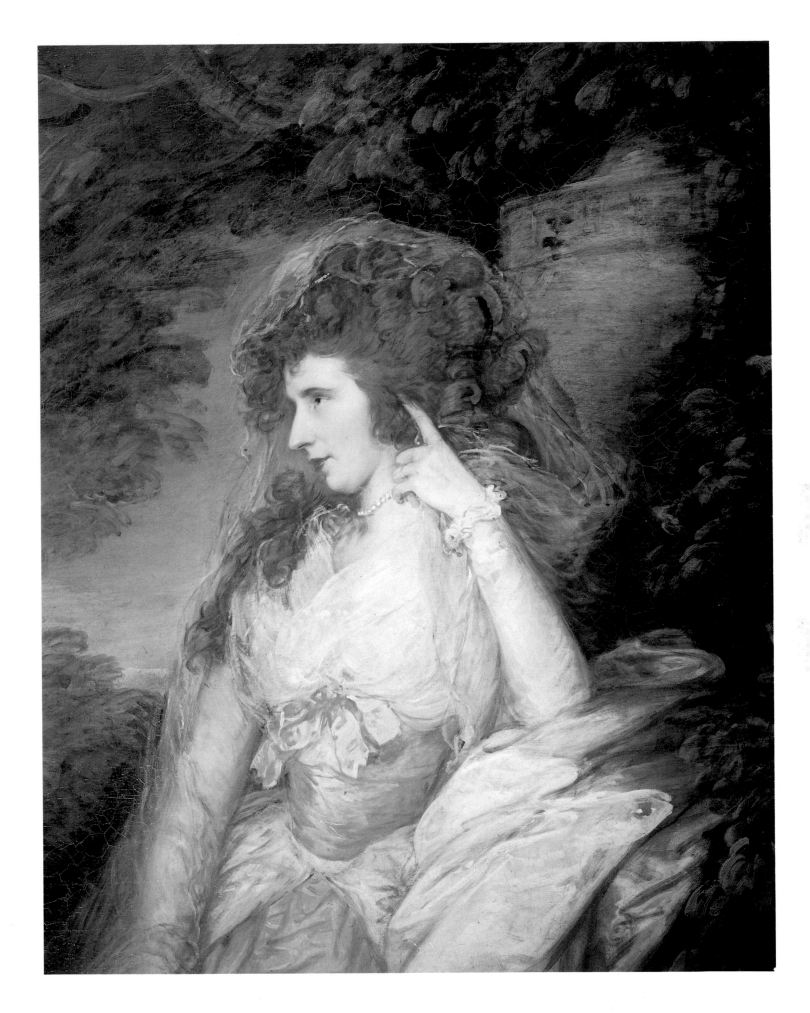

31. THOMAS GAINSBOROUGH, R.A. (1727–1788): *Lady Bate-Dudley* (detail). 1787.
Birmingham, City Art Gallery (on loan from the Burton family)

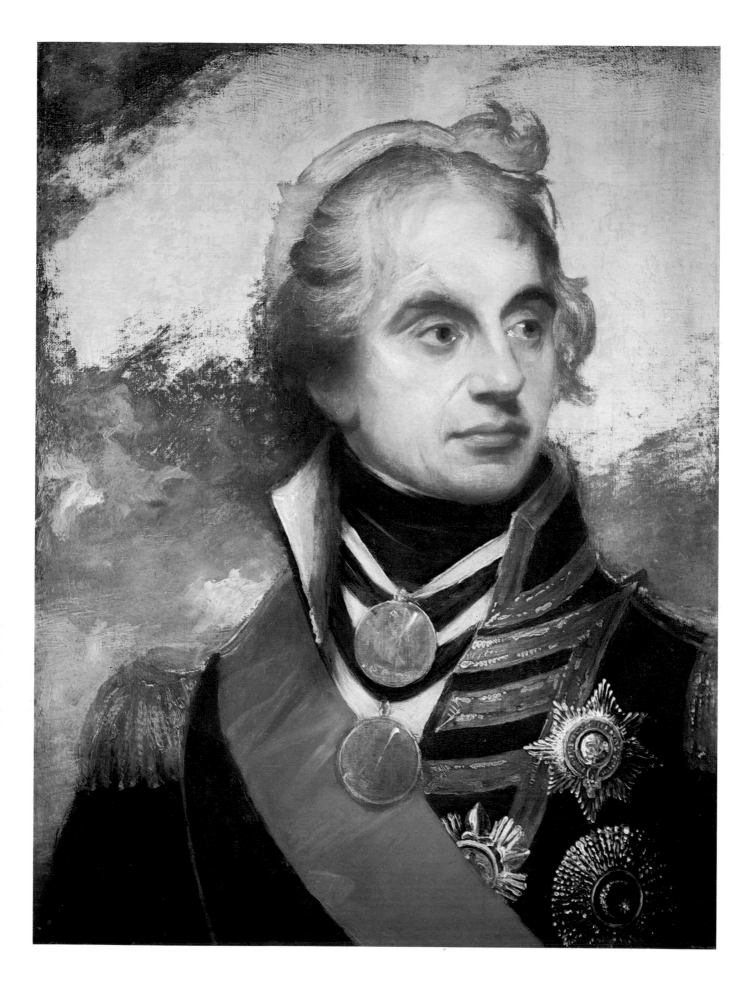

32. SIR WILLIAM BEECHEY, R.A. (1753–1839). *Horatio Lord Nelson* (1758–1805). 1800/1.
London, National Portrait Gallery (on loan from the Leggatt Trustees)

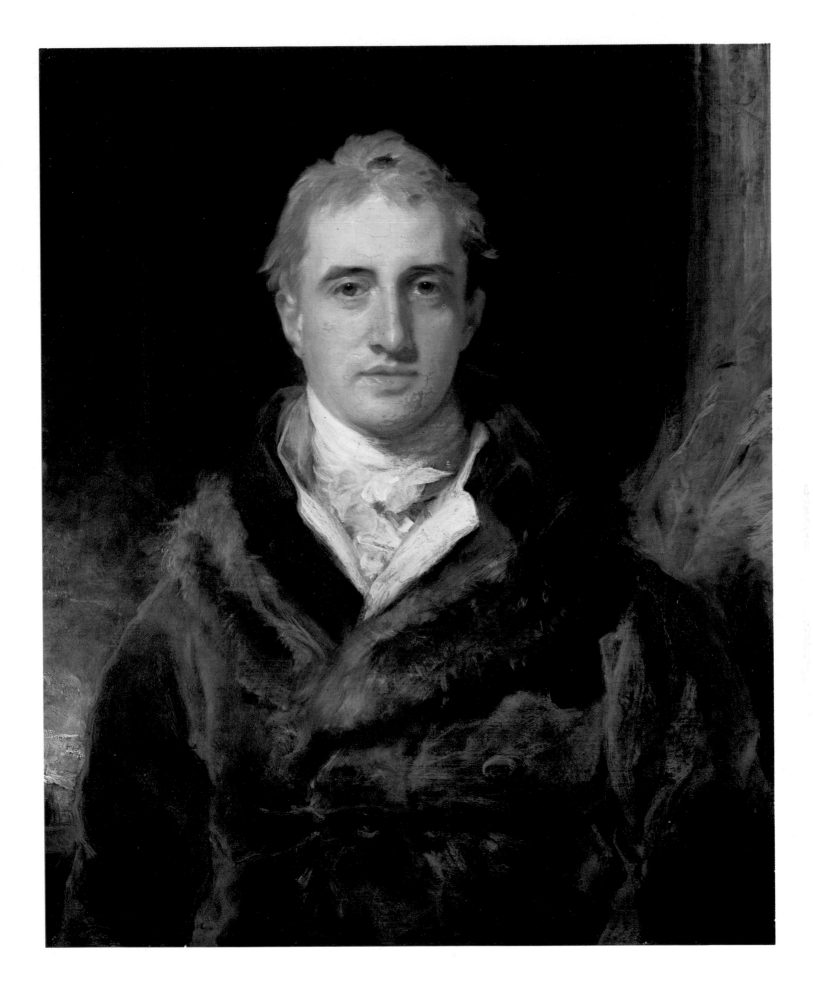

33. SIR THOMAS LAWRENCE, P.R.A. (1769–1830): *Viscount Castlereagh.* 1810.
London, National Portrait Gallery

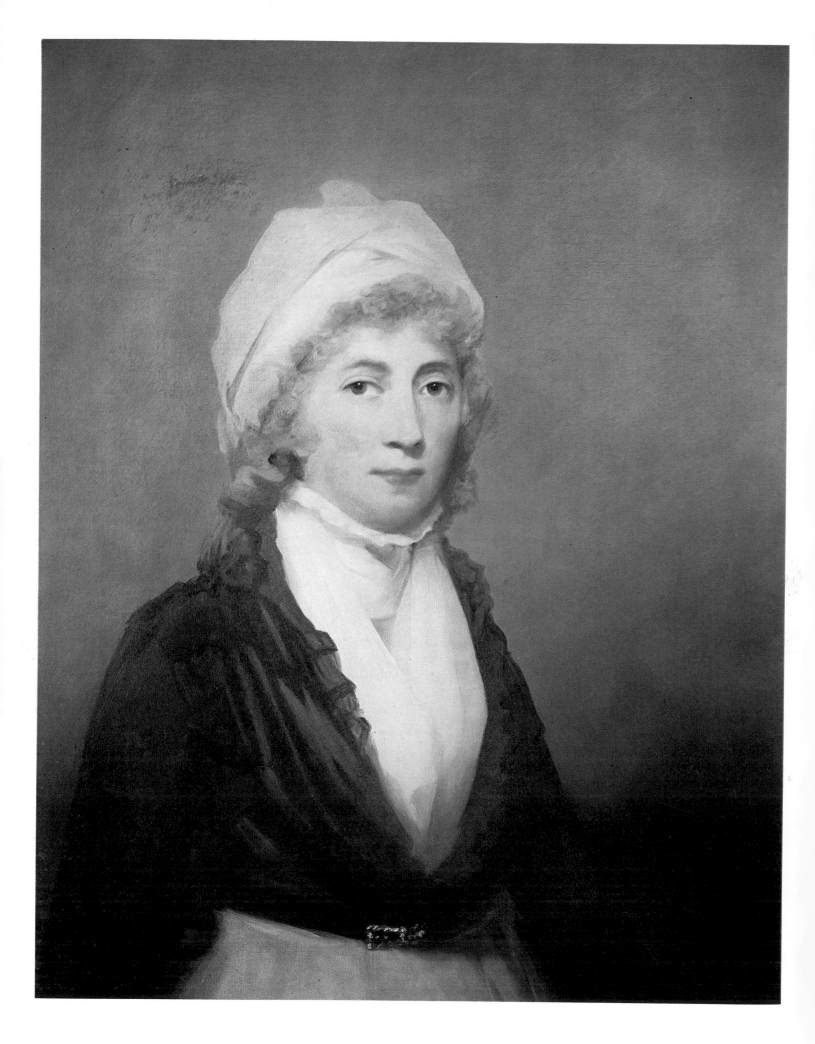

34. SIR HENRY RAEBURN, R.A. (1756–1823): *Lady Dalrymple*. About 1794. London, Tate Gallery

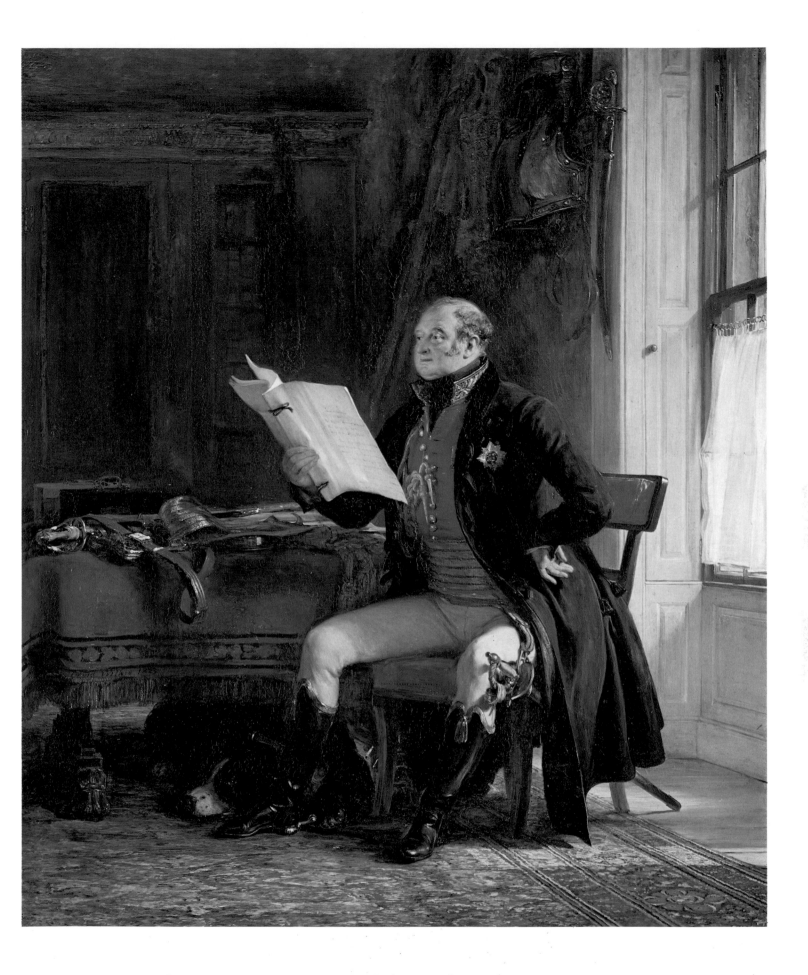

35. SIR DAVID WILKIE, R.A. (1785–1841): *Frederick, Duke of York* (1763–1827). 1823.
London, National Portrait Gallery

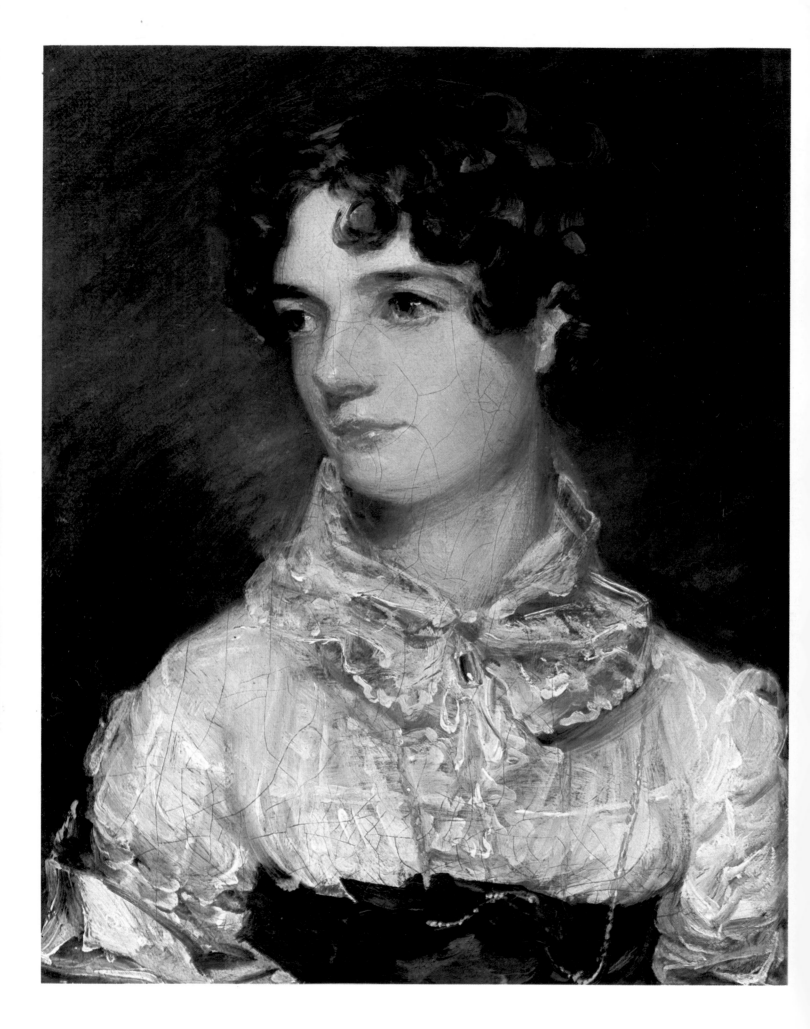

36. JOHN CONSTABLE, R.A. (1776–1837): *Maria Bicknell (later Mrs Constable)*. 1816.
London, Tate Gallery

37. WILLIAM ETTY, R.A. (1787–1849): *Self-Portrait*. 1825. Manchester, City Art Gallery

38. ALFRED STEVENS (1817–1875): *Mrs Mary Ann Collmann*. 1854. London, Tate Gallery

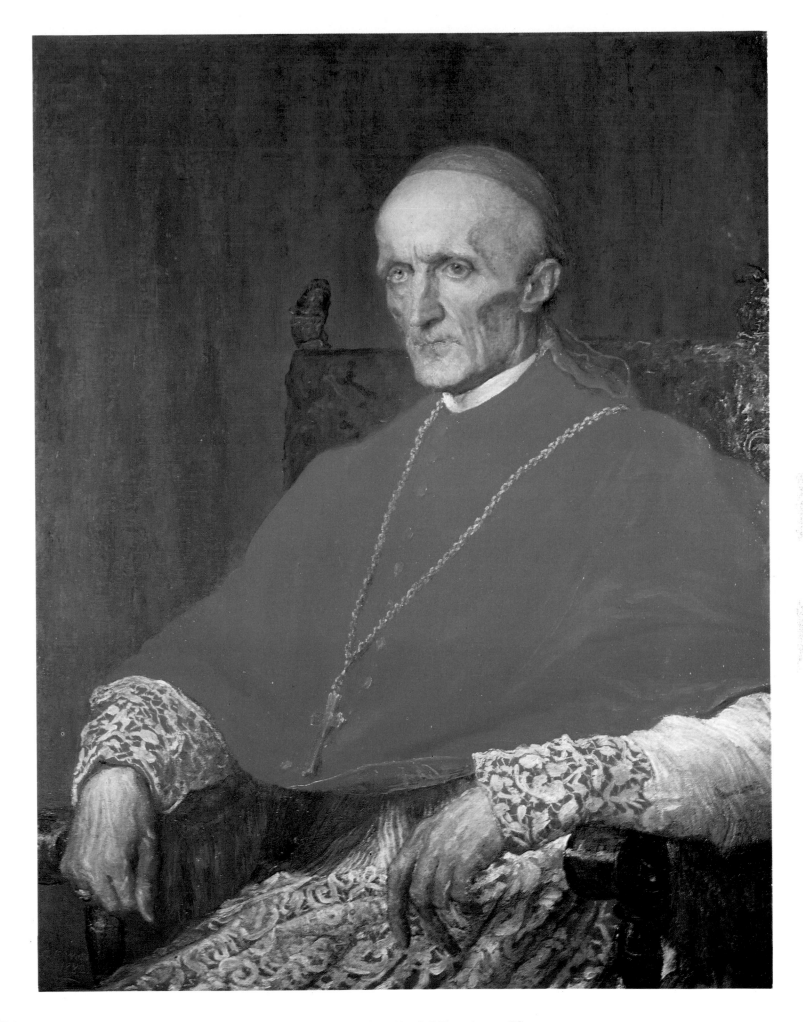

39. GEORGE FREDERICK WATTS (1817–1904): *Cardinal Manning*. 1882.
London, National Portrait Gallery

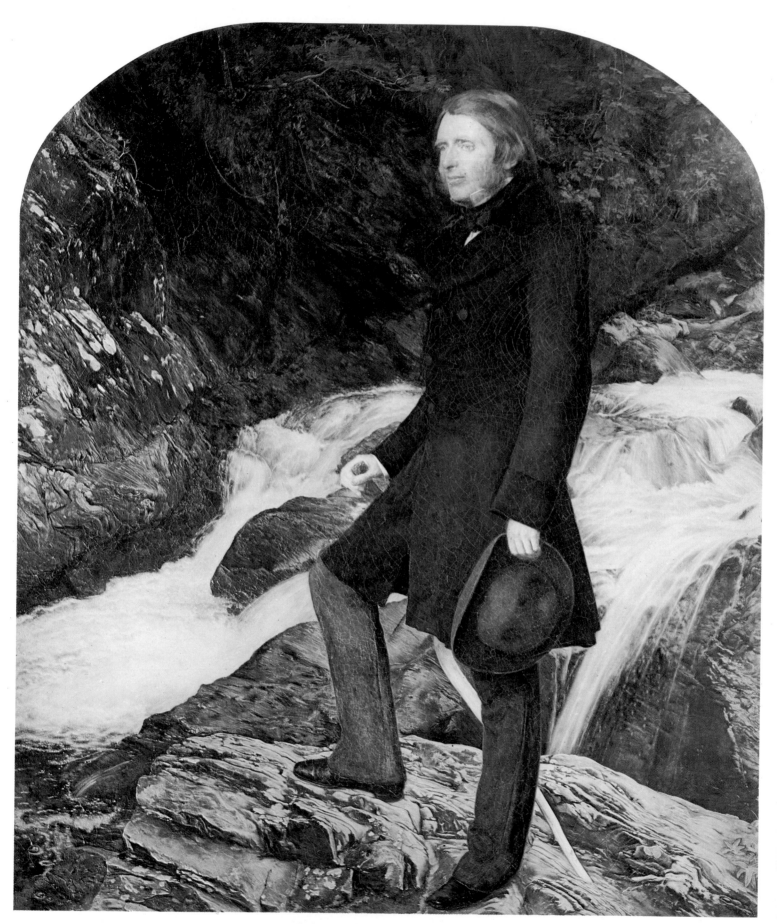

40. SIR JOHN EVERETT MILLAIS, P.R.A. (1829–1896): *Portrait of John Ruskin.*
Signed and dated 1854. English Private Collection

41. JAMES MCNEILL WHISTLER (1834–1903): *Harmony in Grey and Green:*
Miss Cecily Alexander. About 1872–4. London, Tate Gallery

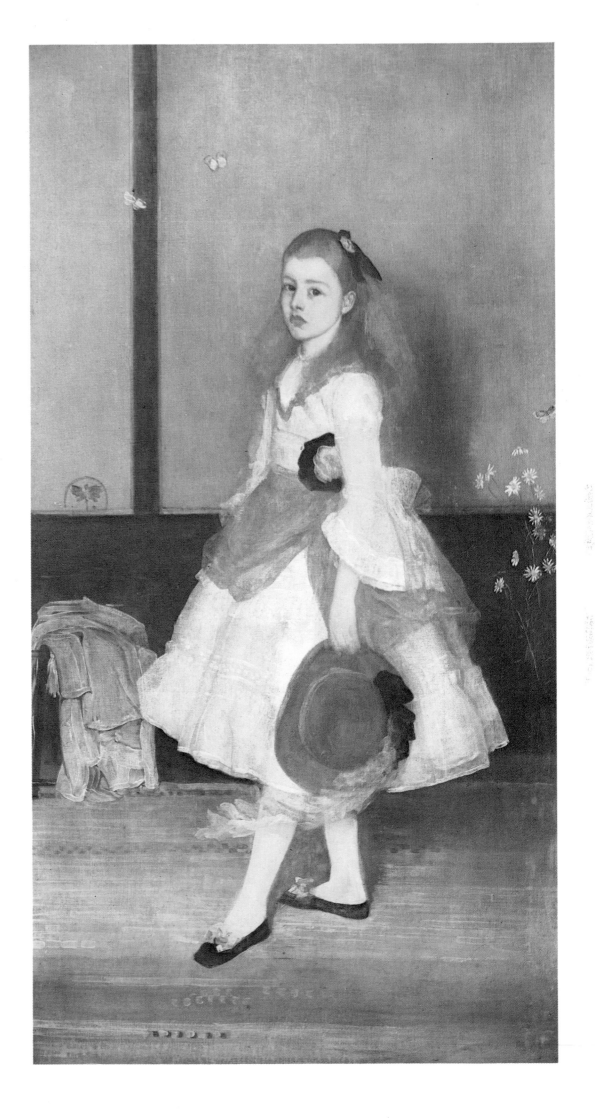

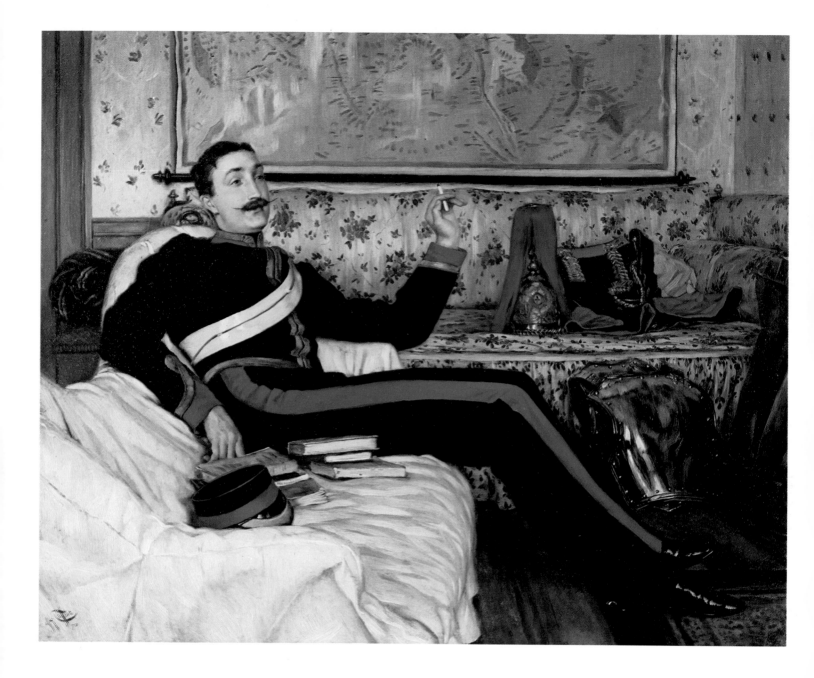

42. JAMES JACQUES JOSEPH TISSOT (1836–1902): *Frederick Burnaby*. 1870.
London, National Portrait Gallery

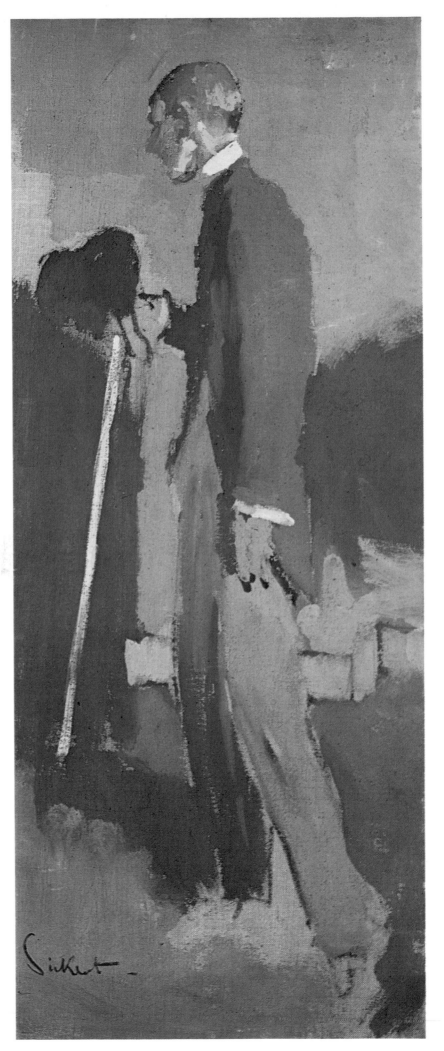

43. WALTER RICHARD SICKERT (1860–1942):
Aubrey Beardsley. 1894.
London, Tate Gallery

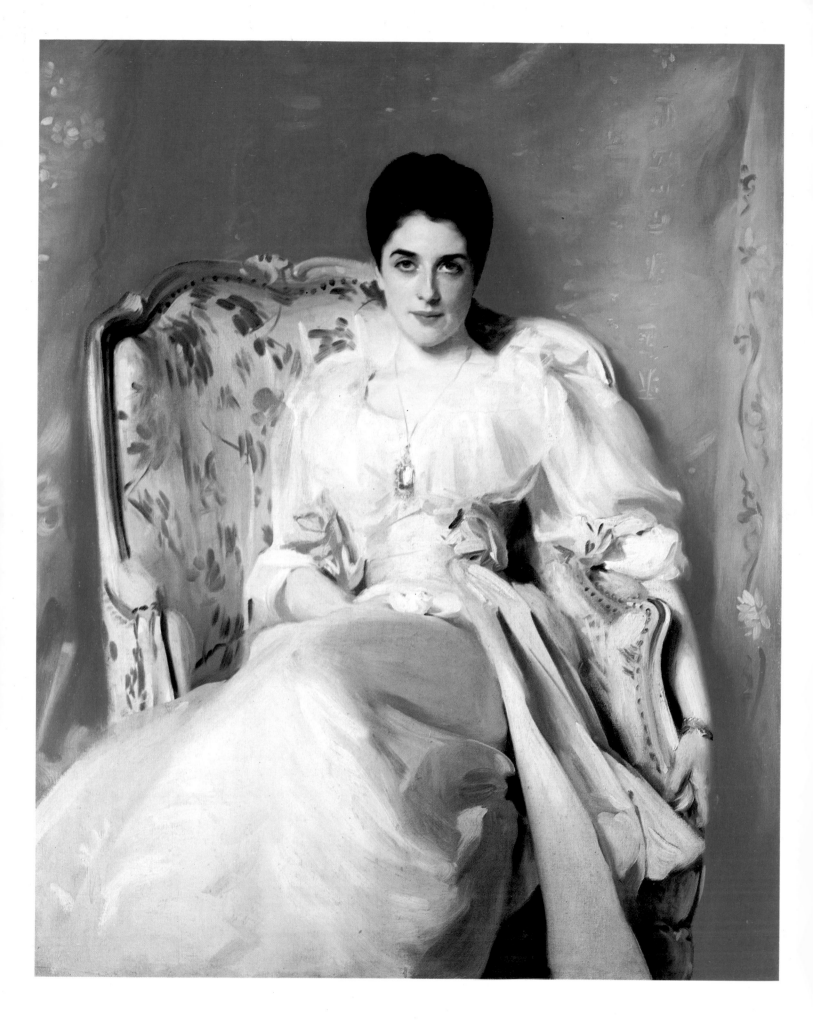

44. JOHN SINGER SARGENT (1856–1925): *Lady Agnew*. About 1892–3.
Edinburgh, National Gallery of Scotland

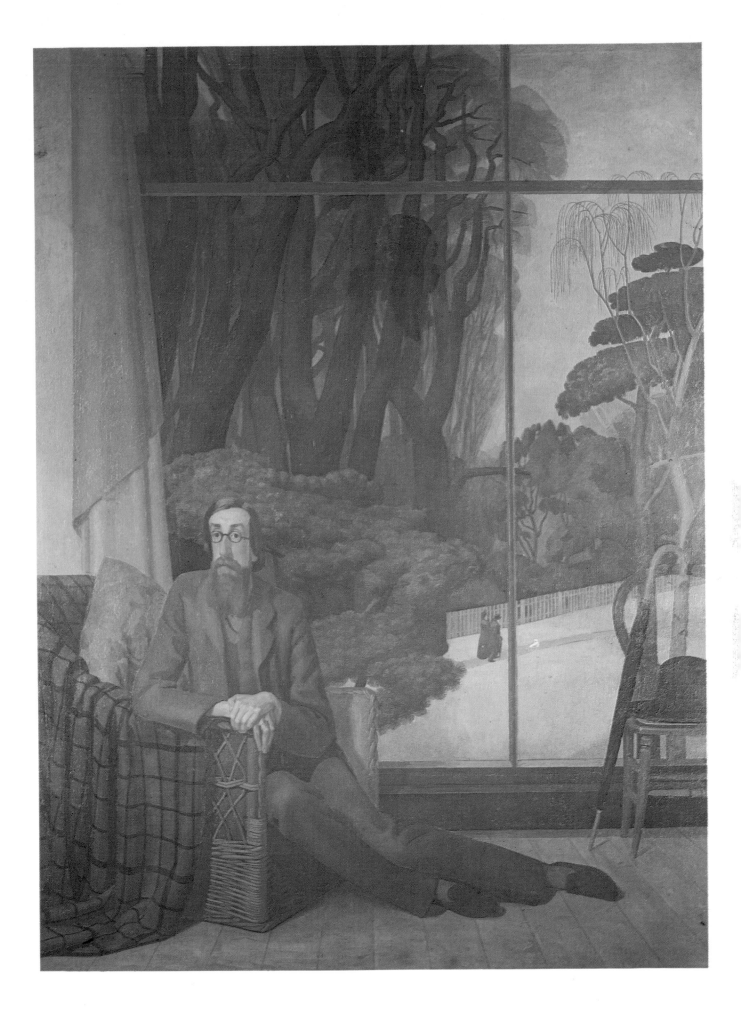

45. HENRY LAMB (1883–1960): *Lytton Strachey*. Completed in 1914.
London, National Portrait Gallery (on loan from the Tate Gallery)

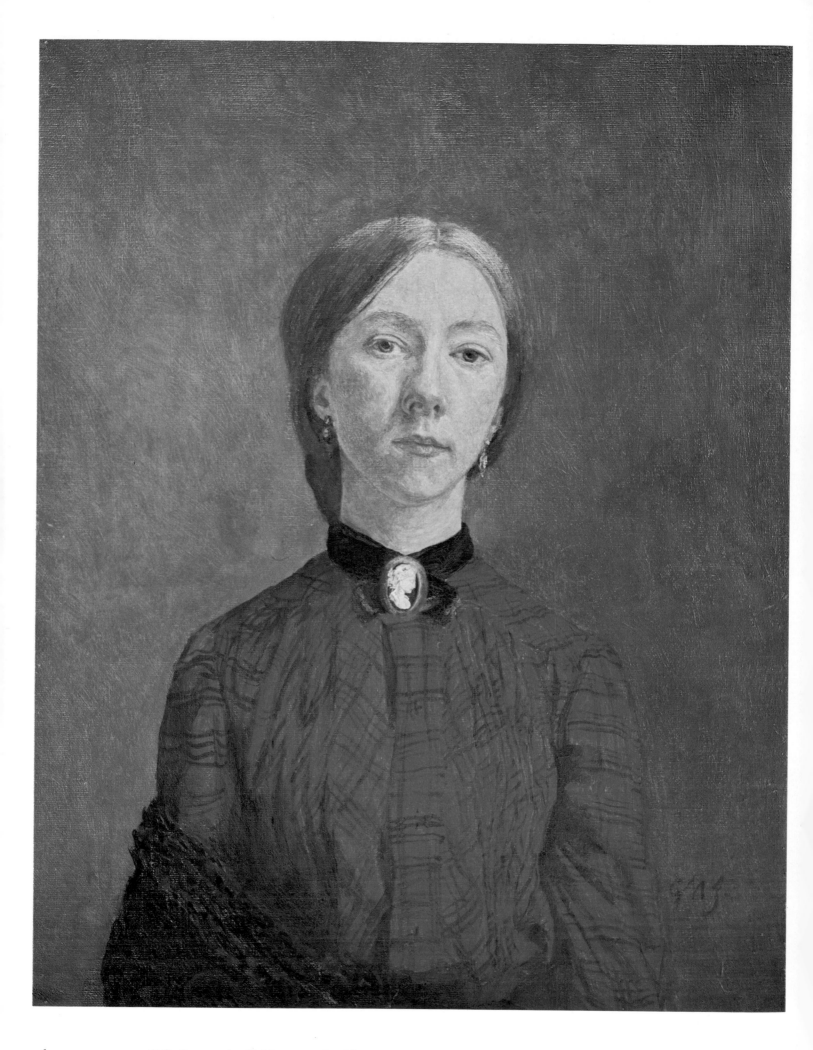

46. GWEN JOHN (1876–1939): *Self-portrait*. About 1899–1900. London, Tate Gallery

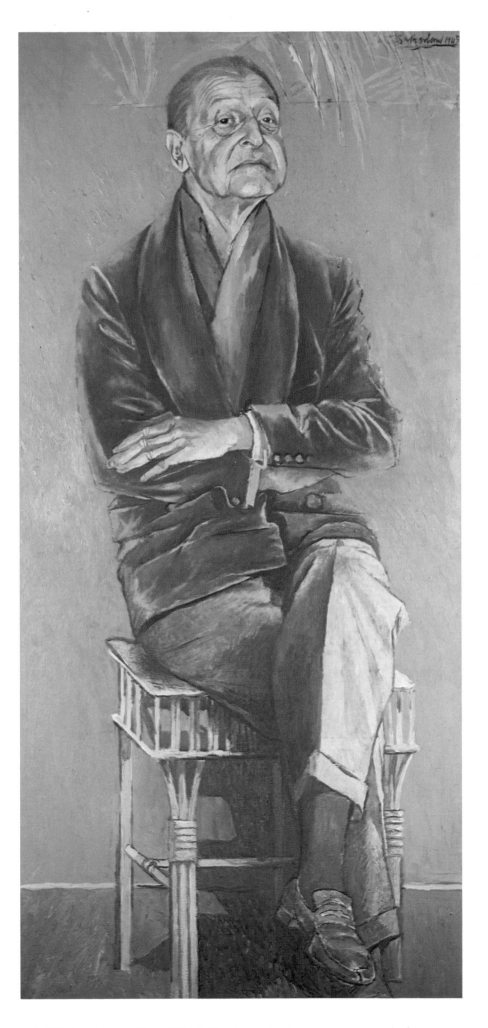

47. GRAHAM SUTHERLAND (born 1903):
W. Somerset Maugham. 1949.
London, Tate Gallery

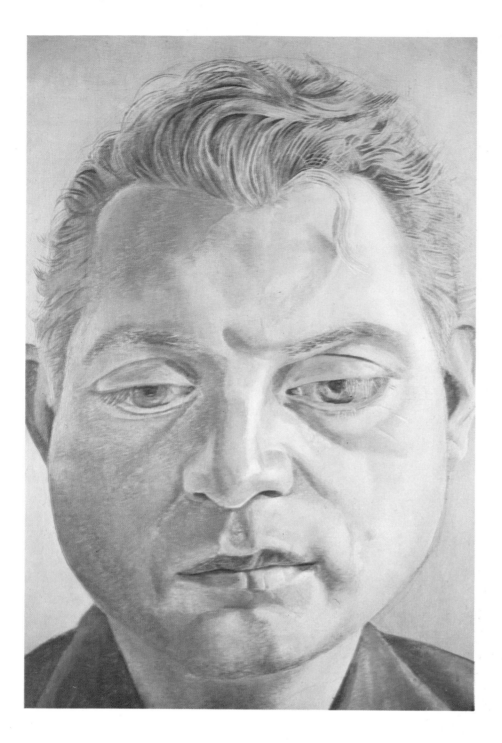

48. LUCIAN FREUD (born 1922): *Francis Bacon*. 1952.
London, Tate Gallery